IN THE SPIRIT OF THE

HAMPTONS

This book is dedicated to my parents,
who encouraged my visual and practical education.
Without their support, this book could not exist.

© 2002 Assouline Publishing
601 West 26th Street, 18th floor
New York, NY 10001
USA
Tel.: 212 989-6810 Fax: 212 647-0005
www.assouline.com

Text edited by Jennifer Ditsler

Proofread by Matthew Malady

ISBN: 2 84323 255 4

Color separation: Gravor (Switzerland)
Printed by Grafiche Milani (Italy)

KELLY KILLOREN-BENSIMON

IN THE SPIRIT OF THE

HAMPTONS

ASSOULINE

"The Eastern end of Long Island, the Peconic Bay region, I knew quite well too—sail'd more than once around Shelter Island, and down to Montauk—spent many an hour on Turtle Hill by the old lighthouse, on the extreme point, looking out over the ceaseless roll of the Atlantic. I used to like to go down there and fraternize with the blue-fishers, of the annual squads of sea-bass takers. Sometimes, along Montauk peninsula (it is some 15 miles long, and good grazing), met the strange, unkempt, half barbarous herdsmen, at that time living there entirely aloof from society or civilization, in charge, on those rich pasturages of vast droves of horses, kine or sheep, own'd by farmers of the eastern towns. Sometimes, too, the few remaining Indians, or half-breeds, at that period left on Montauk peninsula, but now I believe altogether extinct."

Walt Whitman, *Specimen Days*

Contents

PAGE 6-7: *A map of the Hamptons, Long Island, New York, no. 1, designed exclusively for George Glazer.*

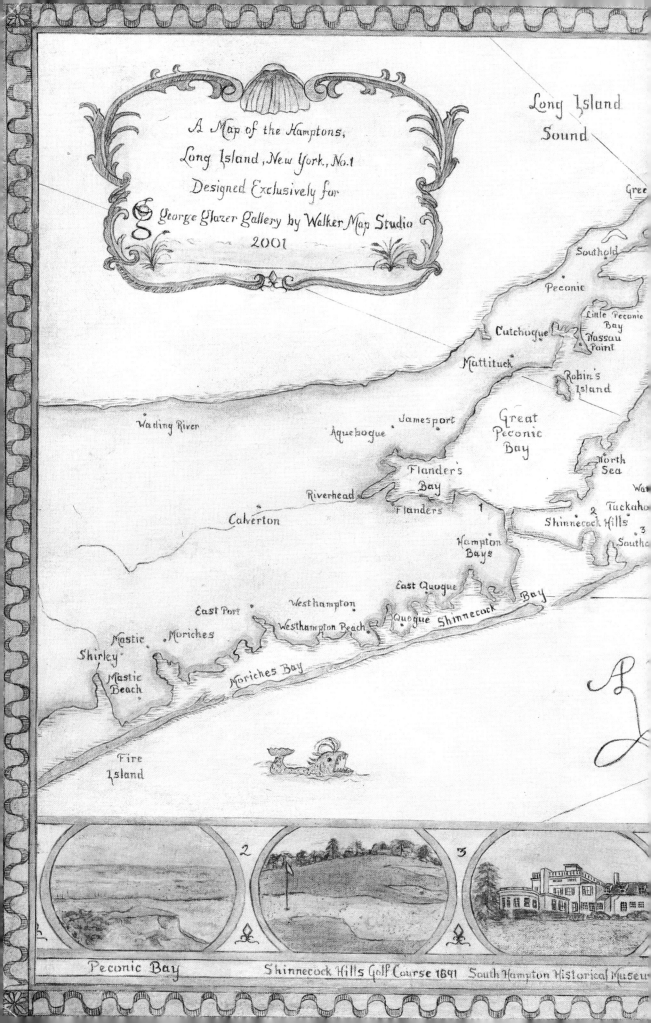

A Map of the Hamptons,
Long Island, New York, No.1
Designed Exclusively for
George Glazer Gallery by Walker Map Studio
2001

Long Island
Sound

Gree

Southold

Peconic

Little Peconic
Bay

Cutchogue
Nassau
Point

Mattituck

Robin's
Island

Wading River

Jamesport

Aquebogue

Great
Peconic
Bay

Flander's
Bay

North
Sea

Riverhead

Flanders

Wat

Tuckaho

Calverton

1

2
Shinnecock Hills

3

Southa

Hampton
Bays

East Quogue

Bay

Westhampton

East Port

Quogue
Shinnecock

Westhampton Beach

Moriches

Mastic

Shirley

Mastic
Beach

Moriches Bay

Fire
Island

2

3

Peconic Bay

Shinnecock Hills Golf Course 1891

South Hampton Historical Museu

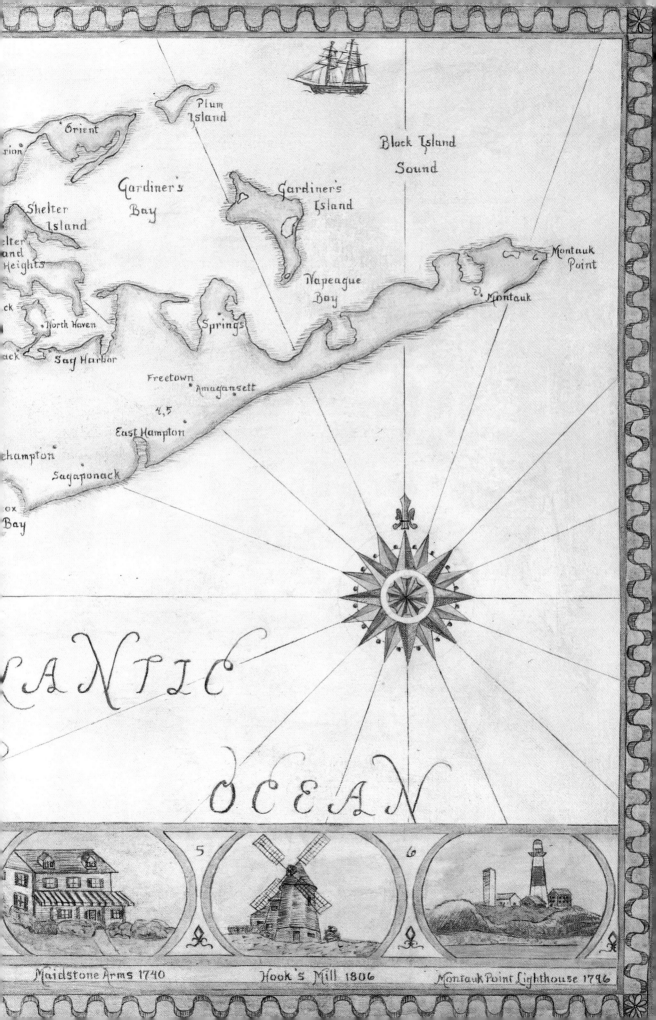

Orient

Plum
Island

rion

Gardiner's
Bay

Gardiner's
Island

Black Island
Sound

Shelter
Island

lter
and
Heights

Napeague
Bay

Montauk
Point

ck

North Haven

Springs

Montauk

ck

Sag Harbor

Freetown

Amagansett

4,5

champton

East Hampton

Sagaponack

ox
Bay

ANTIC

OCEAN

Maidstone Arms 1740

5

Hook's Mill 1806

6

Montauk Point Lighthouse 1796

Author's Note

From our first encounter, the Hamptons have charmed and intrigued me, and throughout the years they have played an important part in my life. I first met my husband there; we were married and spent our honeymoon there, and now it is where I spend every weekend. One August when I first came to Southampton to model for American *ELLE*, I had the opportunity to work with world-renowned French photographer, Gilles Bensimon. After the shoot, he approached me as I stood on the sidewalk in front of the Southampton Inn and asked if I'd like to go to the movies. So vivid is that day in my memory—I still remember what I was wearing. "No," I said nervously, "I have to get back to New York to see my boyfriend."

"I'll see you in another life," he said as he walked away.

That was ten years ago. And it is another life now. Since that first meeting, we have created a life together filled with our two daughters, our Jack Russell terriers (including Spyder, who was bought in Bridgehampton), friends, horses, the beach, clean air, our garden, and our love.

One rainy August day in 2000, my two-year-old daughter and I went to visit the East Hampton Historical Society, also known as the Marine Museum. She loved the antique wooden fishing boats and the pictures of the various fish that live in the waters around the East End. In the stairwell, I noticed an exhibition of photographs. As I followed my daughter into a room filled with colorful puzzles, books about the sea, and stuffed plush fish, I stopped to look at some of the black-and-white pictures: weathered fishermen pulling massive nets filled with their catch, photos of people who've spent their entire lives near the sea, even a beautiful, moody portrait of a fisherman walking down the beach with seagulls and birds swirling around him. Incongruously placed among all of these portraits was a photo taken by Christie Brinkley of her first husband, musician Billy Joel. Joel was handcuffed and being escorted by policemen. I was fascinated that the Historical Society would exhibit these pictures side by side; after all, what did a shackled celebrity have to do with these wizened fishermen? All of a sudden, it occurred to me that this was the very essence of what I loved about the Hamptons and a part of what made them so unique. As my daughter pulled me from room to room, I began to think about this interesting juxtaposition: how so many different people had lived there, how life there was still such an interesting mix of cultures, lifestyles, occupations, people.

I've toyed with the notion of writing a book about the Hamptons for years, but I had a dilemma; I felt proprietary. I've known the Hamptons in so many guises: first as a model where they provided a beautiful backdrop for fashion shoots for clients, then on my own, exploring the beautiful beaches and resort communities on many weekends, over many years. It wasn't until my boyfriend rented a home there that I began spending a lot of time, not just as a weekend destination but during the week and in the off-season. Sometimes I would even go there just for the day. That's when I really started to appreciate the real Hamptons, beyond the beautiful resort community. Before my children were born, I remember investigating places such as

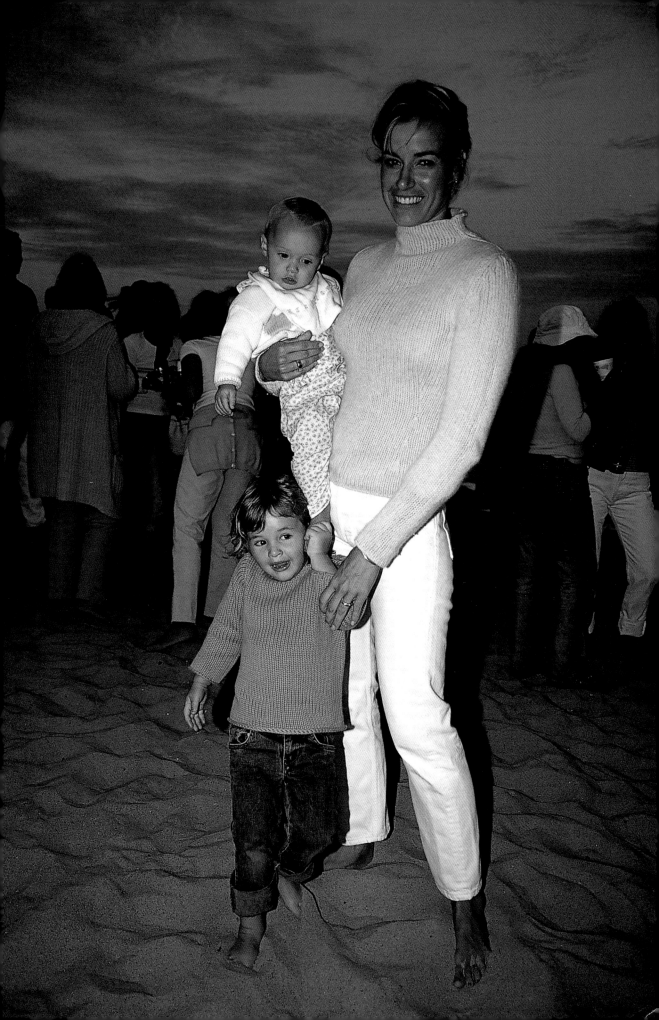

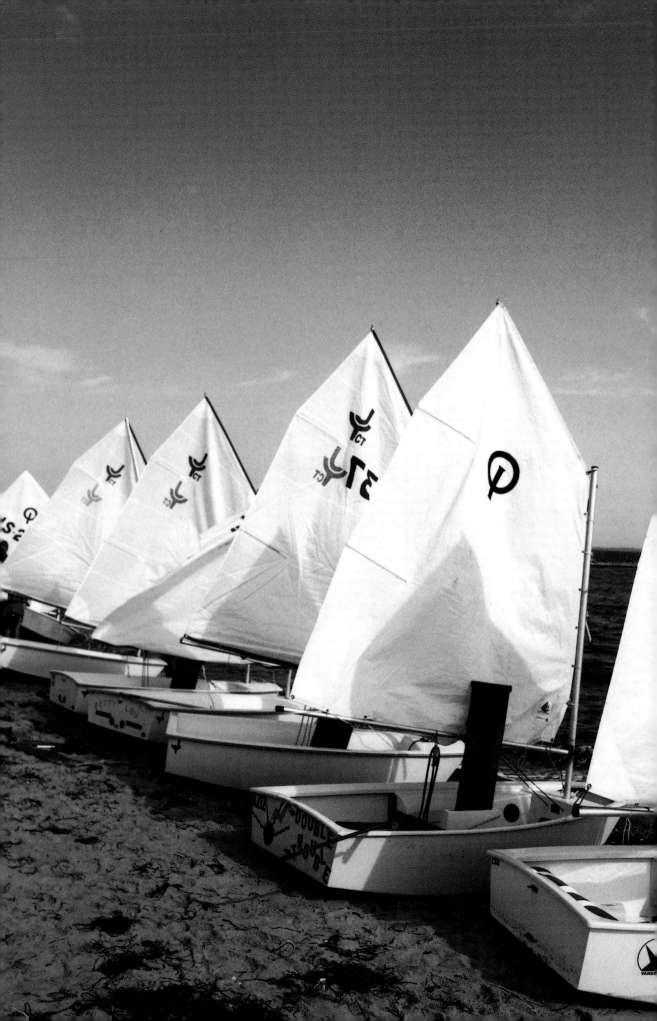

the East Hampton Library, Guild Hall, Fresh Pond, the restaurants, the antique and vegetable markets, and many more places not so evident to weekenders. (I now even pick up garbage as I walk my children down the street on the way to the beach.) It was because of this intimacy that I wanted to create a book that would portray the Hamptons in all their diversity.

For over two years, Prosper Assouline and my husband encouraged me to write this book. But I took my time because I wanted the experience to be intimate. I wanted to create a book that would leave the observer with the feeling that she had been a participant in all that the East End of Long Island represents. And I wanted to preserve the integrity of an area that holds so many different histories and perspectives. My duty, as I saw it, was to describe the nature of this beautiful place and its inhabitants—the tourists, the locals and the luminaries who have helped make it famous. I wanted to explore, not exploit.

Six years ago, I started a column for the *Hamptons Magazine* called "In the Spirit of" where I took themes that originally seemed incongruous with Hamptons' style only to find how deeply those juxtapositions defined the area. One summer I wrote about colors. Another summer I wrote about hedonism, luxury, beauty, etc. This book, *In the Spirit of the Hamptons*, is an extension of that initial idea—a walk through the Hamptons with me as your tour guide.

Visually, *In the Spirit of the Hamptons* is a compilation of photographs from famous photographers, photographers on their way up, and amateurs who just love taking pictures. The common denominator of all of these photos is the emotion they convey. Each photograph tells a story, and each story sheds a little light on the beautiful and intriguing mystery behind the "Do Not Enter" signs, the manicured privet hedges, the topography, the legend and the lore.

Introduction

The first time I visited the South Fork or East End of Long Island, also known as the Hamptons, I was seventeen. It was April, and I was there with two other models for a testing—which means you are being photographed but not getting paid. After two long hours on 495-East, a monotonous four-lane highway among vast stretches of open fields and not much else, I began to wonder when we would get there and what could possibly be so great about this place. The first thing I saw as we took exit 70 to 27-East was a gas station and a hot dog stand, not too exciting. Then I saw a huge red deer sculpture. Bunnies jumped in and out of the grass separating 27-East, a four-lane road that narrows to two lanes as you pass the Shinnecock canal. At the Lobster Inn restaurant, 27-East was no longer a highway stretching across Southern Long Island, but rather a two-lane road known as Montauk highway. All of sudden it wasn't just any road anymore, but the beginning of a journey—traffic slowed down, and the Hamptons opened up.

It seemed that every fall and spring I was in the Hamptons to model—typically viewing the landscape from a motor home, nose pressed against the window with makeup on my face and

PAGE 9: *Author, Kelly Killoren-Bensimon, at a* Hamptons Magazine *summer beach party held at Flying Point Beach, near Mecox Bay.*

PAGE 10: *Sailboats at the Devon Yacht Club on the bay side of Amagansett.*

ABOVE: *Bridget Hall, on a beach in Southampton, not far away from the Shinnecock Inlet which was created by the hurricane of 1938.*

PAGE 15: *Beach Lane is one of the prettiest streets in Wainscott; farmland stretches to the ocean on one side and traditional homes line the other.*

curlers in my hair. As an outside observer, I wondered how people could live all year around in such a remote place. Although close to New York, it was still a three-hour trip, even at 6 A.M. with no traffic. But each time I passed through, all the many things I saw out the window began to seem familiar and even predictable: the sand that covered the sides of the streets, signs marked for deer crossing; notices for summer concerts at Southampton College, the Shinnecock Golf Club; marine stores; Morgansen's auctioneers; Corrigan's domestic auto shop; the vast farmland both north and south of the highway; nurseries; tile stores; an American flag at half mast; pick-up trucks loaded with mulch. Ruby Red's antique shop always seemed to have old metal beds on its lawn. Sag Pond Farm's Grand Prix field was so close to the road that I could almost feel the power of the horses as they jumped over water and galloped down hills. The Old Stove Pub's vacant field sat empty awaiting another antiques fair.

These small towns were so real and well maintained—governed by New York City standards and cash flow. I quickly noticed, just from my window, that the Hamptons were a combination of farmland, horse farms, delis, and wealthy summer inhabitants who maintained perfectly pruned hedges. So, it was real in the sense that it was authentic. You could get a coffee from the deli and mingle with the local men, but you also noticed that it was so well maintained and manicured. The picket fences were all white and perfectly painted. The shingles on the homes were all the same color, whether old or new. It was the perfect rural community, cared for by both the villagers and by the wealthiest New Yorkers.

Certainly, over the years there has been change, but the changes seemed subtle enough that they simply blended in—real estate offices opened, houses got bigger and the open land less vast, but there is still a feeling of Old World charm that prevails. I loved the familiarity of the place and its incongruities piqued my interest. In East Hampton, you could count on the ducks wait-ing to be fed in the creek that opens into Hook Pond. And some of the lawns are better manicured than the golf courses. But this seemingly effortless effect was really due to the deter-mined efforts of some very dedicated people. The elm-trimmed streets, the pond (a home for beautiful swans in the summer and a great ice skating rink in winter) creating a uniquely pic-turesque scene, and the European charm, are all protected by the Ladies Village Improvement Society in East Hampton and the town's strict zoning board.

All kinds of people from all walks of life are scattered throughout the Hamptons from Southampton to Montauk; windsurfers and sailors, artists and celebrities. But whether the popu-lation is 8,000 or 200,000, the Hamptons always seem to stay the same—open farmland, brick-paved sidewalks, oceanfront homes, quaint villages, lush trees, gorgeous beaches, warm salty air, and a light so pure that artists like Willem de Kooning and Jackson Pollock claimed they could find no equal.

Throughout all of my travels to the Hamptons over the past sixteen years, they have changed very little, but my view of the area has changed drastically. There are so many ways to experi-ence the Hamptons. In 1992, a friend of mine had a summer share in Bridgehampton. I loved the idea that I could get away from the city in just three hours, versus visiting my parents all the way in Rockford, Illinois. One thousand dollars for every other weekend and I never made it there that summer, not once. Years later, when I was in my mid-twenties, my sister and I would go to the Hamptons for the weekend, and I also experienced several nights in a share house. "I'm going to a party, and I can't bring anyone with me," a housemate announced. I was shocked; my

mother raised me to always bring houseguests to a party, but this house had over 15 people sleeping on what seemed like every possible surface—not a welcome entourage! But I was experiencing the social scene in the Hamptons. Sometimes we would go to five different bars or parties in one night. I was young and I thought that was fun; however, I quickly learned that the party scene got boring really fast. But after a run down the beach in the clean ocean air, all I could think about was getting back the next weekend.

It is a place of contrasts and there is no escaping the fact that its beauty and charm, and the proximity to New York, has made it a favorite place for the wealthy and the famous. One summer my twin brother and I were staying at the Village Latch motel in Southampton. We rented bikes and went to Flying Point Beach. As I ran down the beach I couldn't help but notice John Kennedy Jr. playing volleyball while Darryl Hannah sat watching nearby.

The first time I was in a horse show at Sag Pond Farm, I was very nervous to show, especially when I heard that my division would be "adult equitation," which literally means the rider rides the horse in walk, trot, and canter. As I struggled to calm my nerves I turned around to see a cool and collected Caroline Kennedy in my same class. I managed to place third out of four, which I was very happy with. I chose not to remember what place Caroline received.

That fall, a college friend invited me to Southampton for the day. His parents had a beautiful home on Halsey Neck. We walked to the beach and ate sandwiches from the deli in town while watching pickup trucks fishtail down the beach. It was there that I began to really see the Hamptons. What I saw was that all of these crazy juxtapositions: young and old, socialite and artist, Old Guard and new rich, surfer and banker, are the colors on the canvas. The Hamptons are the canvas. There will always be artists who gravitate to East Hampton, there will always be people who visit for the day or weekend—if they can get a hotel room. And, there will always be people like me who come in as an observer looking through the window, watching others on the beach, viewing the scene in the clubs, and running on the warm sand.

Later that year, I modeled in East Hampton and stayed at the Maidstone Arms Hotel. I remember the night fog rolling off the ocean as I jogged past the Maidstone Club and down Further Lane. That night I ate "Killer Mexican" at the Blue Parrot, a local restaurant where I now eat all the time with my daughters. I remember that night as perfectly as I remember the day I met my husband; the tree-lined streets, the charming English hotel room, the run down Further Lane, the fog, and the Mexican food.

It was after that weekend that I became a participant. Even though I didn't yet own a house, I still felt a sense of propriety. A year later, my husband and I got married, built a house and started a family there.

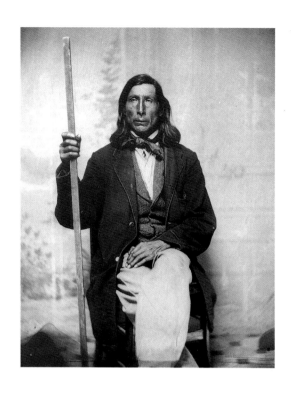

Origins

The South Fork of Long Island extends approximately 120 miles from New York City. The southern peninsula on an approximately 40-mile stretch of land is known as the Hamptons. This area is configured into two townships, Southampton and East Hampton, connected via a single two-lane highway, 27-East. The villages within Southampton township are Southampton, Water Mill, Bridgehampton, Sag Harbor and Sagaponack. East Hampton township is comprised of Wainscott, East Hampton, Amagansett, Napeague and Montauk. Shelter Island and Gardiner's Island are situated in the bay between the North and South Forks of the East End. According to the lore, the Hamptons begin at the Shinnecock canal which separates the rest of the Hamptons from Hampton Bays, West Hampton, Quogue and Riverhead. (Technically, Southampton extends as far west as Eastport.) Although generally considered part of the Hamptons, 27-East does not run directly through these villages as it does all the others.

The East End of Long Island is typical to the East Coast in that there are 300-year-old trees, hundreds of acres of

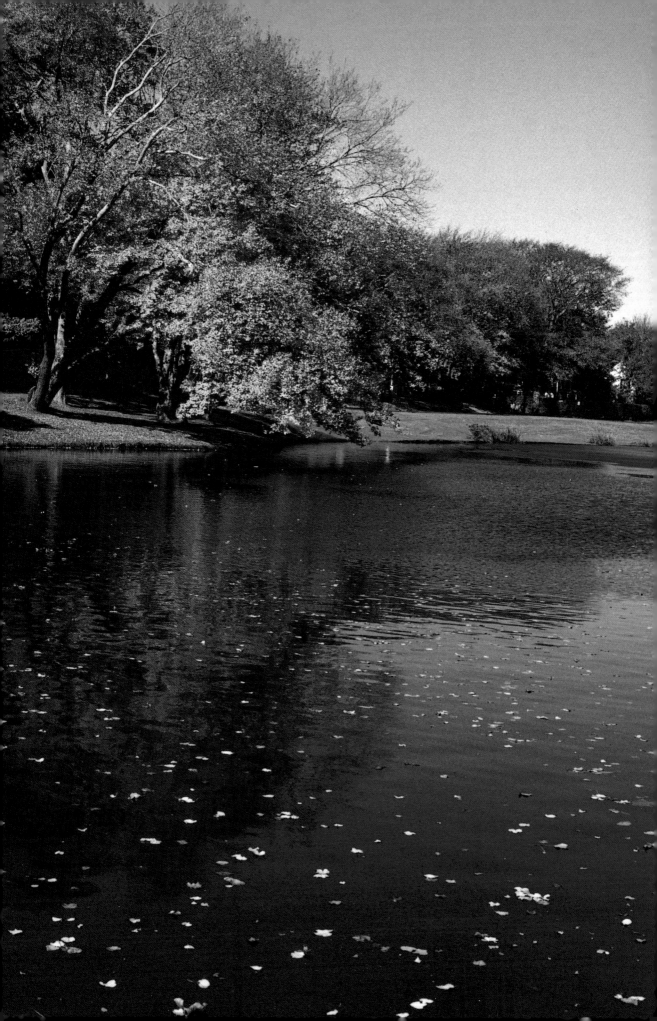

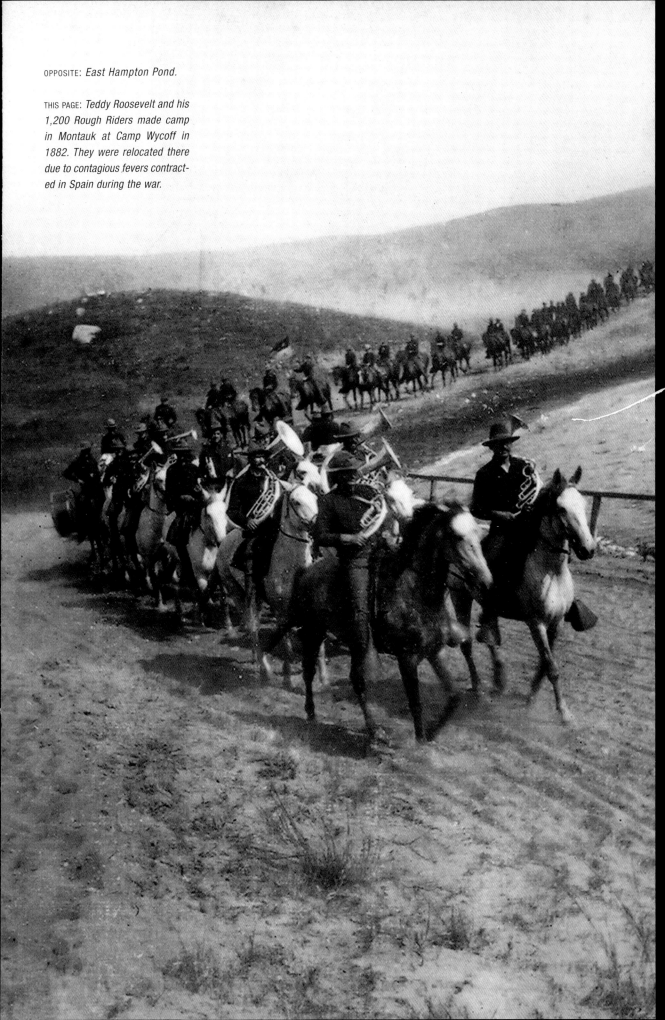

OPPOSITE: *East Hampton Pond.*

THIS PAGE: *Teddy Roosevelt and his 1,200 Rough Riders made camp in Montauk at Camp Wycoff in 1882. They were relocated there due to contagious fevers contracted in Spain during the war.*

farmland, voluptuous dunes and sea cliffs, and gorgeous beaches. But it is unique in that these various landscapes exist within a 40-mile stretch. Its rich, fertile soil, abundant marine life and abundance of fresh water have made it ideal for those seeking to make their living from land and sea for millennia. For several thousand years before the first English settlers arrived, Shinnecock, and Montaukett Indians—among many others, all of the Algonquian tribe—migrated to the sea to enjoy the cool sea breezes during the summer, and in winter moved inland where there was plenty of dense forest for fuel and shelter.

In 1640, the first white settlers landed at Conscience Point on Peconic Bay in Southampton, and after some bloody skirmishes struck an uneasy balance between the settlers and the Native American inhabitants, due in large part to the abiding friendship between chief Wyandanch of the Montaukett and Lion Gardiner, one of the first and most influential English settlers to the area. Gardiner, no doubt with his own best interests in mind, had helped Chief Wyandanch and his Montaukett tribe defend their lands against invading Narragansett Indians, thus demonstrating his potential for loyalty and friendship. Though no pacifist, Gardiner held a greater respect for the original inhabitants than his royal benefactors back in England, who advocated a much less humane approach. Gardiner set about finding peaceful ways to live together with

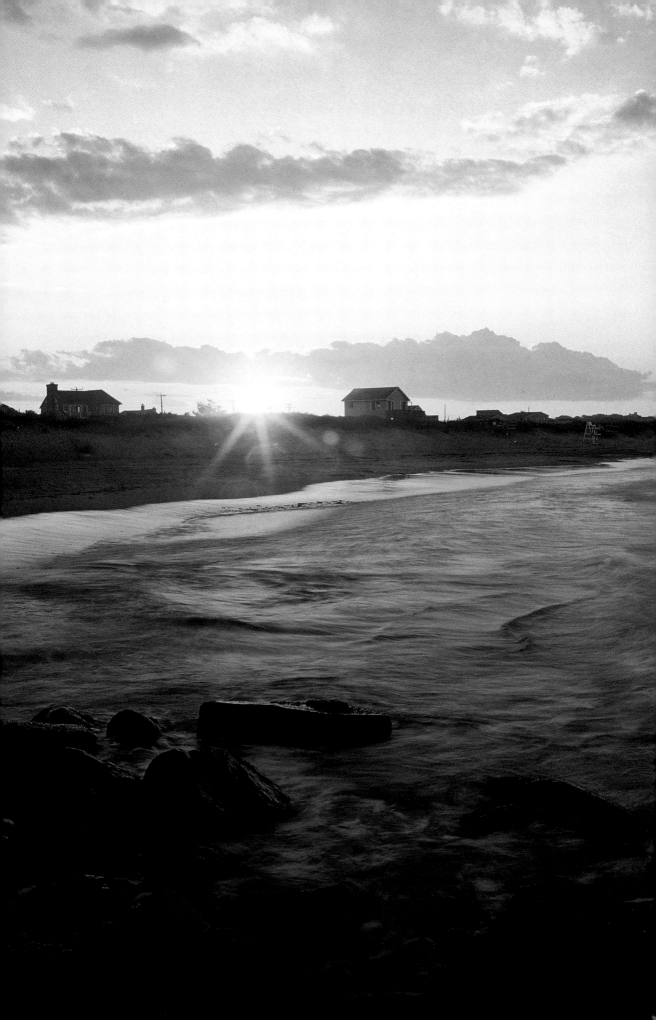

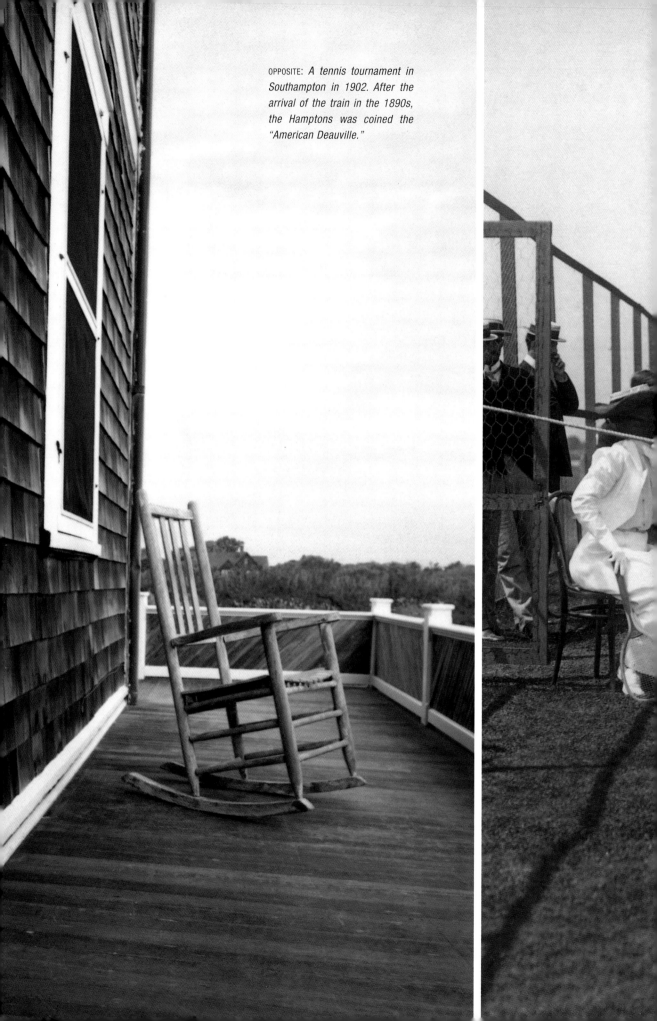

OPPOSITE: *A tennis tournament in Southampton in 1902. After the arrival of the train in the 1890s, the Hamptons was coined the "American Deauville."*

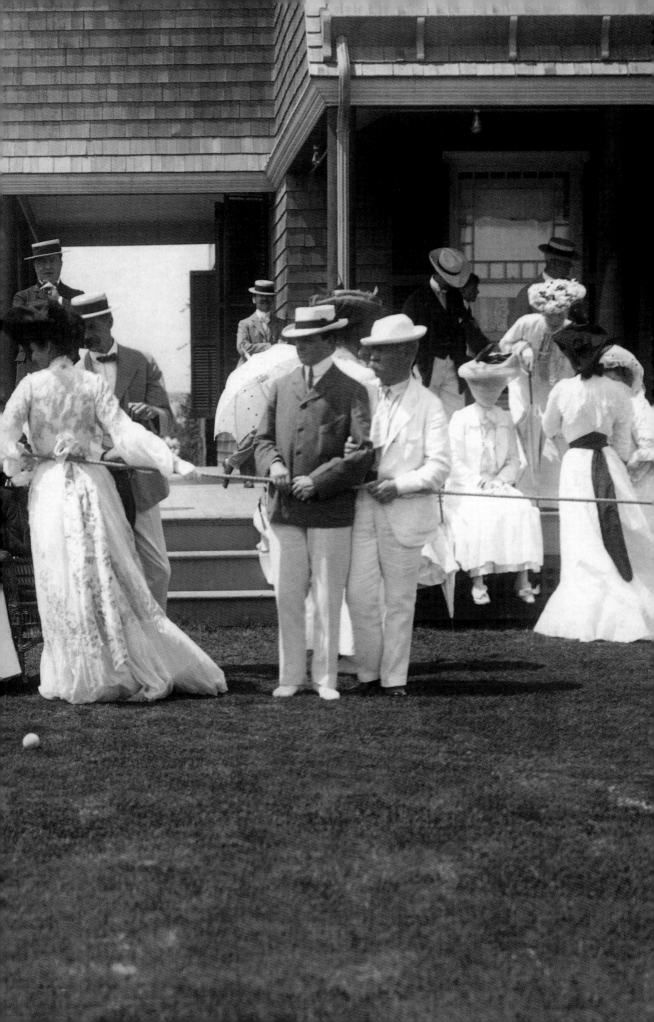

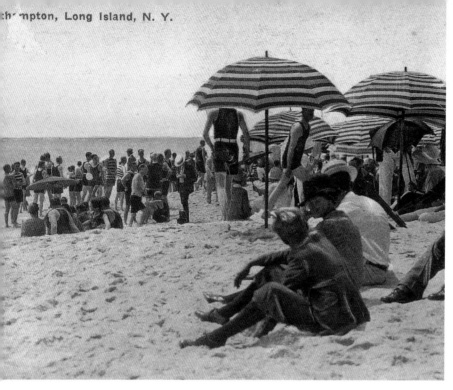

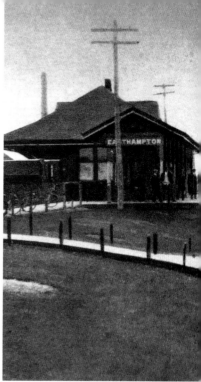

the Native Americans rather than living in a constant battle zone where no one felt safe. The history of the Hamptons has always been a story of tension between the "old guard" and the new. This was certainly true for the native tribes who, within a mere 350 years were driven from the lands they had lived on for centuries. The story, unfortunately, is not a new one, and even the land allotments created early in the century to protect the remaining Native American peoples proved easy to circumvent. Such is the story of Montauk, the last lands still farmed by the Montauk tribe in the early 1900s.

Montauk was actually purchased from the Montaukett Indians in 1879 by Arthur W. Benson, a captain of industry who intended to make a major port out of this far tip of the South Fork and would need to bring the railroad through for transport of cargo. But there was a problem. He would have to find a way to relocate the last significant tribe of Montaukett Indians who had already been pushed to the far reaches of the Island and had no motivation to leave (even if there'd been somewhere left to go). So, he initiated a series of lawsuits claiming that due to widespread integration among the Montaukett tribe, their way of life had become so adulterated that they no longer qualified as a "culture" and therefore were not protected under the Northwest Ordinance Treaty of 1787, which stated that the lands could not be taken without the Indians' consent (this law was mostly theory anyway, in practice it was largely ignored).

LEFT TO RIGHT: *Bathing beach at the turn of the Century; Steam locomotive at the East Hampton railroad station 1909; Residence of Grange Sard in Southampton.*

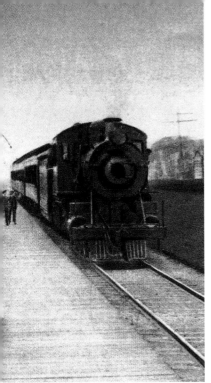
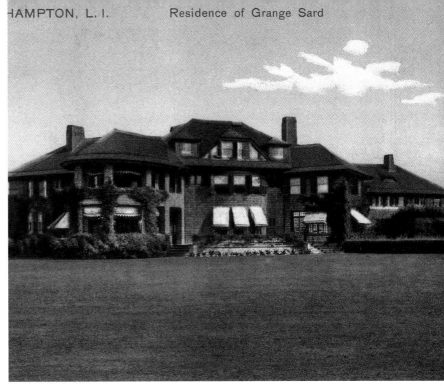

The question of what to do with the old guard was final-
ly settled on October 10, 1910. Wyandanch Pharaoh, chief of
the Montaukett tribe and descendent of Lion Gardiner's close
friend, was notified that the Benson family, the Montauk Dock
and Improvement Company, Alfred Hoyt, the Montauk
Extension Company and the Long Island Railroad Company
had won the rights to his homeland. Justice Abel Blackmar
denied the Montaukett Indians their Indian field because there
was "no existing tribe of Montaukett Indians"—that is, in the
judge's estimation the culture was no longer alive. The entire
Indian community was relocated from the Indian field in
Montauk to Freetown, between the Springs, Fireplace Road
and Three Mile Harbor in East Hampton. There, the Indians
were not really welcomed by the Bonackers—the natives
descended from the first English settlers· and another "old
guard"—who worked the land there. But a community was
established nonetheless. As stated in a Brooklyn Eagle article
of 1910, "the Montauk race whose name has been given to so
many things from theatres and 'swell clubs' to prize fighting
arenas, and 'buy–your–own–home' town lots. . . has been driv-
en off the land." Pocahontas Pharaoh was the last Montauk
Indian to be born on the Indian field of Montauk. She died on
February 6, 1963.

Almost all that remains of Indian culture in the Hamptons
are the towns and streets that bear their names. During Labor
Day weekend there is a Pow Wow and before you enter

Southampton there is a fabricated tepee and a stand where Indians sell cigarettes. Bob Pharaoh, the current Montaukett Chief and Grand Sachem of Long Island is responsible for carrying on the Montauk tradition. Although today there are over 600 documented members of the Montauk nation, they are now scattered around the country. Pharaoh supports the annual Pow Wow because it brings Native Americans together, makes the public more aware of the presence of the indigenous peoples on the East End, and helps in his struggle to regain the culture and the land.

It is remarkable that to this day a single two-lane highway provides the only ground access to or from the Hamptons. As charming as this seems, it carries with it implications that reach far beyond its summer traffic jams. Route 27-East, or Montauk Highway, stretches nearly 40 miles to Montauk point about three miles inland and provides an important demarcation for those to whom status is important—in other words, nearly everyone who visits or resides in the Hamptons. Real estate south of the highway carries with it the highest pricetags due to its proximity to the ocean. Property types range from ocean-front mansions to vast estates on winding roads, to charming cottages, village homes, and lovely farms. These have increasingly become the exclusive neighborhoods of the very rich. Exclusivity and status-consciousness is as much a part of the Hamptons as potato farms and sparkling beaches. Although the fortunes of many have ebbed and flowed, from the 1600s when English Puritans wrestled the land from the Indians out from under the Dutch, real estate has probably provided the primary and perhaps most revealing history of the Hamptons.

In the 1860s, boarding houses run by local residents—who quickly learned the value of renting to summer vacationers—were the first lodgings available to intrepid tourists brave enough to make the long and dusty trip by coach. But the lure of the Hamptons has always been such that those who visited usually fell under their spell and soon people were buying up land to build their own homes. The fate of the Hamptons was sealed by the time the railroads reached East Hampton in 1895.

With a finite amount of land, land acquisition has always been a push and pull between many different factions with many competing interests. Often those interests are paradoxical: those who wish to keep the exquisite beauty of the land and its resources intact and those who wish to profit by it are not

OPPOSITE: *The Presbyterian Church in Bridgehampton was built in 1843 in the Greek Revival style with columns and capitals. Presbyterians have worshiped in Bridgehampton since 1690. When the structure was just a home, parishioners would walk to the beach in Southampton to worship there.*

always different parties. The old guard and the new find themselves living in a precarious dance so complex and intertwined that it almost defies description, as exemplified by such organizations as the Ladies Village Improvement Society, which has never let any amount of money or prestige sway their loyalty to the East End. No matter how seemingly obtrusive, their practicality has preserved much of what makes East Hampton so desirable.

But, regardless of status, part of what makes the East End such an interesting place is how everyone—from industrialists and self-made millionaires to artists, celebrities, weekenders, fishermen and farmers—lives side-by-side in relative harmony. Although always sought after, there were real estates bargains to be had. Estates in any of the townships were never cheap, but small carriage houses and farmhouses were. Real estate maven, and close friend of Andy Warhol from his illustrating days, Tina Fredericks has many stories illustrating the changing fortunes of Hamptons real estate. She boasted one afternoon about how she bought a carriage house on 2 1/2 acres for $6,500 in the late 70s which is now worth somewhere in the neighborhood of $1.5 million. But perhaps the most telling is the story of Eothen in Montauk, the old Richard Church estate of the Arm and Hammer Baking Soda family which she sold to Andy Warhol for $225,000 in the 70s and is now worth $50 million. Built in 1931, Eothen had only been on the market once in the last one hundred years when it was sold by Church's daughter to Warhol. Under Warhol's ownership, Eothen became a summer hideaway for Lee Radziwill, Jackie Onassis, Mick and Bianca Jagger, Halston, Elizabeth Taylor, and Liza Minnelli. Under its present owner, it has been rented out for myriad photo shoots as well as to summer vacationers like Julian Schnabel and the Duchess of York. The average cost of an acre of land in the Hamptons in 1960 was $10,000; in 1980 it was $125,000, and in the year 2000 you could purchase one acre for a mere $500,000. Now, the story of the Hamptons is nearly always one of excess. Tina tells how she sold the Billy Joel home to Jerry Seinfeld. Apparently, Seinfeld was trying to buy one of the Tyson homes (the Tyson's are one of the oldest Hamptons'

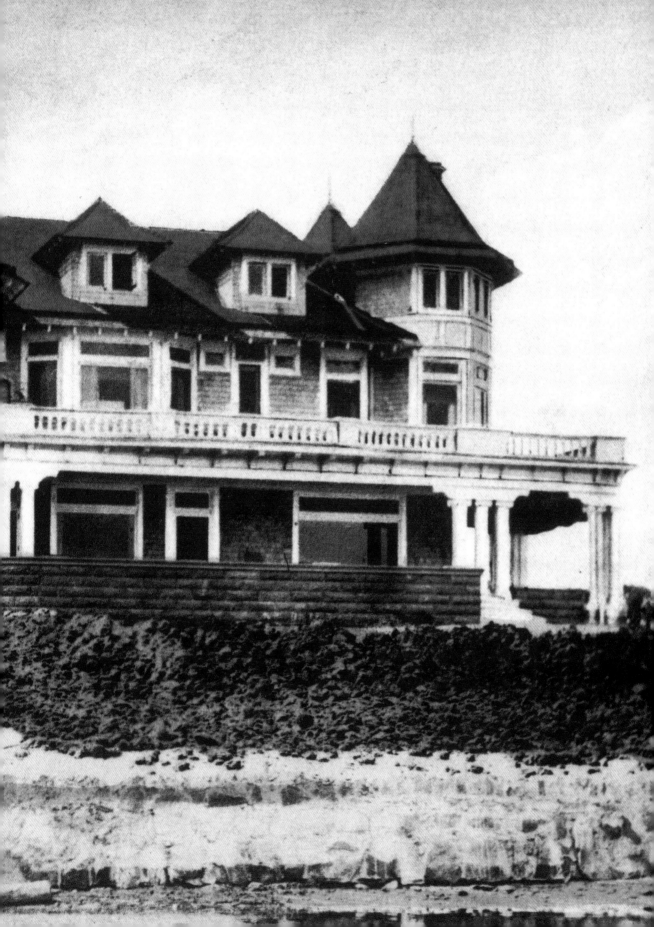

RESIDENCE OF F. C. HAVENS, SAG HARBOR, L. I.

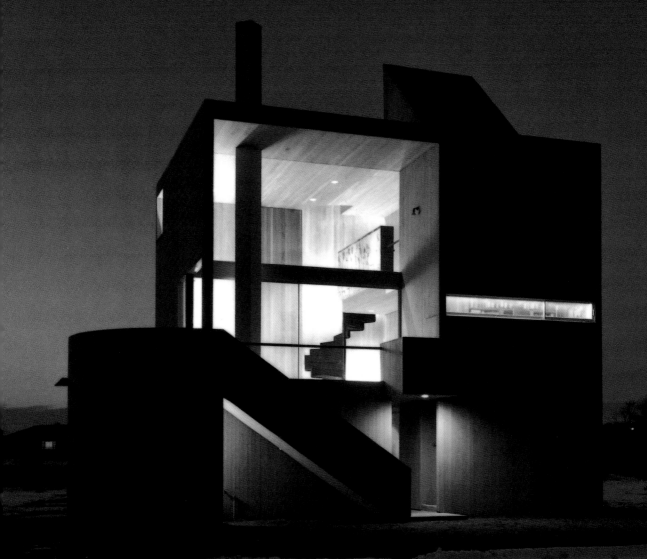

"I built my parent's house in 1965.
Despite changes, the essence, whether
psychological or real, of the Hamptons,
has prevailed: the sense of place,
the edge, the light, the solitude,
the timelessness and romanticism."
Charles Gwathmey

families) on Further Lane in East Hampton, but Helmut Lang bought it out from under him for $14 million. According to Tina, "Jerry didn't want to be known as the one who bought the most expensive house, but he eventually did. . . the Billy Joel home for $35 million." Tina also sold Sean Puffy Combs a home in East Hampton, where his infamous "white party" is held. She also sold Ron Perelman "The Creeks," a notorious mansion on Georgica Pond in East Hampton whose story is great Hamptons' lore.

Even the size of homes in the Hamptons runs the spectrum. In Bridgehampton, the Rennert house, dubbed "the house that ate the Hamptons," is over 80,000 square feet, sits on 60 acres, has 100 bedrooms and its own bowling alley, and is the biggest house in America (bigger than the White House). Barry Trupin gothic castle, dubbed "Dragon's Head," complete with an imported bar from Normandy, indoor grotto, indoor pool and a fish tank with exotic fish, including sharks, was originally built for Henry F. du Pont as an elegant beachfront-style mansion. It was transformed by its new owners into a 55,000-square-foot castle, apparently without much regard for local zoning laws—the Trupins were embroiled in lawsuits until the owner, up to his neck in difficulties, finally sold it off. Although the new owner has toned it down a bit, it still remains an anomaly whose quirky exterior fascinates tourists.

There are private farms with million dollar horses, and on the whimsical side, there are estates with stairs that play the *Star Wars* theme, and underground basketball courts with windows that allow one to view swimmers as they go by. On the other side of the spectrum, near the bay on the north shore of the South Fork, one can find many surfer and fishermen's shacks along Lazy Point of barely one room. What is enduringly beautiful about these modest homes is the breathtaking simplicity of the views: just beach, water and sky.

PAGE 29: *Estate built during Sag Harbor's prosperous whaling years.*

OPPOSITE: *Modern architect Charles Gwathmey's home in Amagansett.*

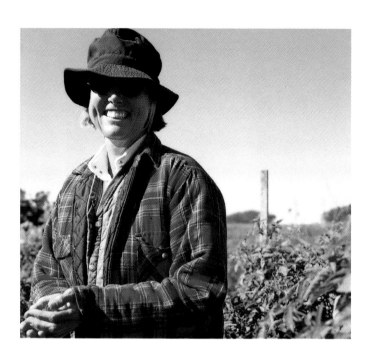

Fish and Farms

The bays have always been a draw for mariners and Montauk Point, whose pale stone cliffs reflected the light of the moon to guide the sailors home, served as an important landmark even before its lighthouse was finally erected in 1796. Indeed, the first major industry in the Hamptons came from the sea. In the 1670s, it is said that whales were so abundant that whalers could catch them right off the beach from small boats. Through the 1800s, whaling brought tremendous prosperity to the area, resulting in its first major economic boom. By the 1800s, however, the whale population was so diminished that sailors were forced to set off for the high seas in search of their increasingly elusive quarry. Finally, in the 1860s, farming and other industries eclipsed whaling, as the demand for whale oil virtually disappeared and whaling was no longer worth the serious risks it posed. But, to this day, the Hamptons have remained a major area for fisherman who find striped bass, sea bass, lobsters, clams, oysters, scallops, and many other marine delicacies.

From the 1600s up until the 1970s, farmland extended as far as the eye could see on both the north and south sides of 27-East. Farming the rich, glacial soil was essential to the

ABOVE: *Landscape architect Edwina von Gall.*

OPPOSITE: *Fishing in at the tip of Montauk is great due to the fact that the bay and the ocean are separated by land. Montauk is the sport fishing capital of the world. Off the tip of Montauk bass migrate and tuna fishing is within 100 miles.*

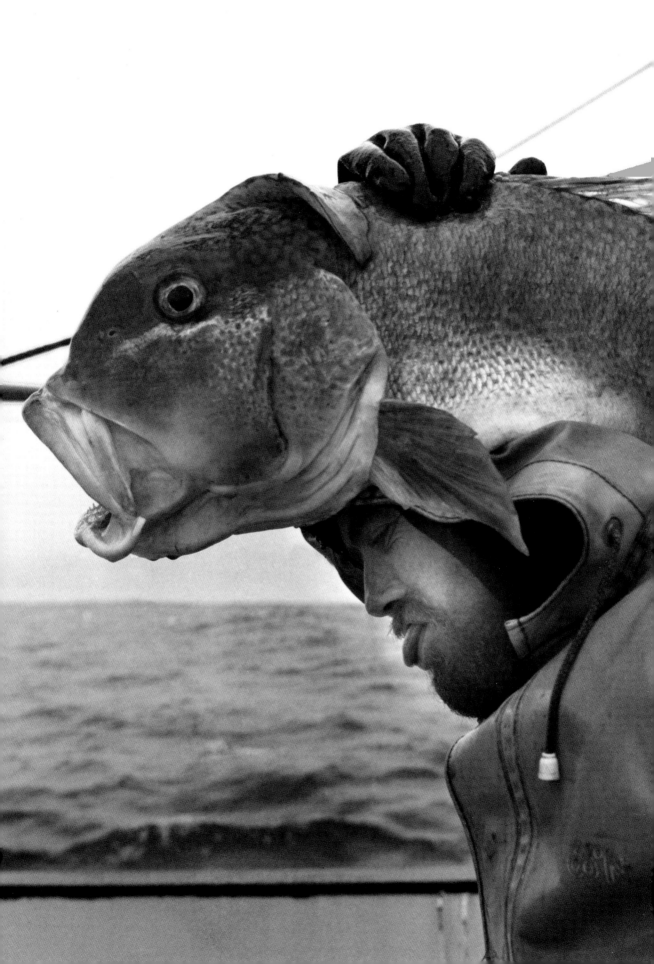

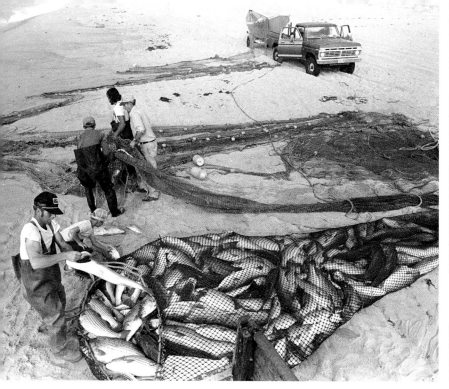

ABOVE: *Beach scene with fish in net Haulseining for striped bass as seen in this photograph taken in the early 1980s was a tradition in a small group of commercial fishing families that was carried on for generations and generations. Highly visible to others who used the same ocean beaches to catch the same fish recreational, this method of fishing for striped bass was declared illegal in 1990 by the New York State Department of Environmental Conservation, "DEC." Ironically, it was members of this same DEC, who in the early 1970s won the fishermen's trust, and began an extensive study, that would provide a key nail in the coffin that symbolizes the end of farming and fishing on the east end.*

livelihood of the Hamptonites who, for hundreds of years, grew many crops, kept cattle, and sheep and built mills for the abundant grains that were harvested there. It was not until the latter part of the 20th century that the potato fields and rolling farmland of the area began to give way to development, and summer tourism eclipsed farming as fuel for the local economy.

But the Hamptons have always been in some sense a summer resort. As early as the 17th century, the Hamptons were coined as "the beach" and "the country," and the "American Deauville." In the 1890s, due to the completion of the Long Island Railroad and the area's sudden accessibility, the Hamptons became the vacation haven of the East Coast upper crust, but not the upper upper crust. According to David Goddard's book, *The Maidstone Links*, those who originally vacationed in the Hamptons were not the Rockefellers, Mellons, Fricks, Astors, or Vanderbilts—who maintained their second homes farther west on the North Shore of Long Island near Locust Valley and Old Westbury—but the more modest

RIGHT: *Fishermen with baskets and birds in air. Crew members aboard the fishing vessel "Patricia E." of Montauk, wash fish on the deck of the 38-foot dragger on a cold winter day. The boat burned and sank in the early 1990s.*

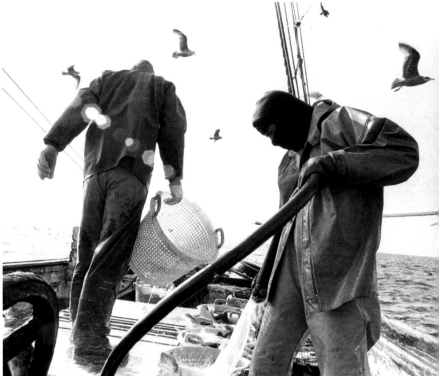

CENTER: *Gosman's Dock.*

PAGE 36-37: *Stuart Vorpahl, right, stands with an unidentified man in a yard probably in Amagansett in the late 1940s. The scene in this photograph, of animal skins drying was once a part of the farming and fishing community that dominated the area for generations. Sadly, that life has all but disappeared from view, and in today's society both of these men would not only be in violation of the law, they would also feel the wrath of more than one animal rights organization.*

gentry. The development of major hotels and luxurious clubs with golf courses contributed to its desirability.

The history of the Hamptons is inextricably linked with the evolution of transportation to the area. In 1733, there were three roads built to transport a few passengers and mail to New York City. These roads stretched the length of the island from New York: one on the North Shore, one on the South Shore, and one in the center.

In 1772, the first coach was established by Samuel Nichols, Benjamin Havens, and Nathan Fordham. It ran between Sag Harbor and Brooklyn once a week in the summer and once a month in the winter. This didn't deter vacationers; once the Hamptons were "discovered," their desirability never abated even though the trip could take as long as three days. In the 1920s, approximately 14,000 people lived in Southampton and East Hampton. In the 1950s the population grew to around 23,000 in the two townships. By 1960, 64,000 people lived there, and in 2000 over 300,000 people were vacationing there from Memorial Day to Labor Day.

PAGE 39: *Tony Curtis on photographer Milton Greene's boat. Greene kept a boat at Shinnecock Inlet. At night, they would look for stripers or striped bass. Joshua Greene remembers fishing off the Long Island Sound and off Montauk. "It is best to use light fresh water tackle and get the angry fish that are trying to run." After fishing, Joshua and his dad would spend many weekends at Adolf Green and Phyllis Newman's house, where guests like Lauren Bacall and Richard Burton would frequent.*

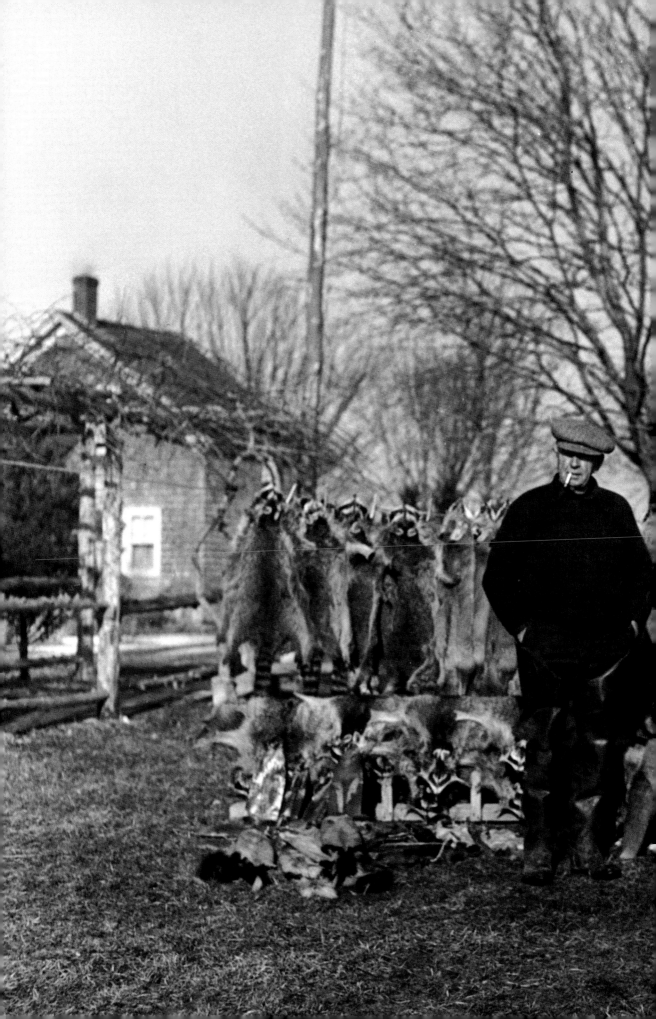

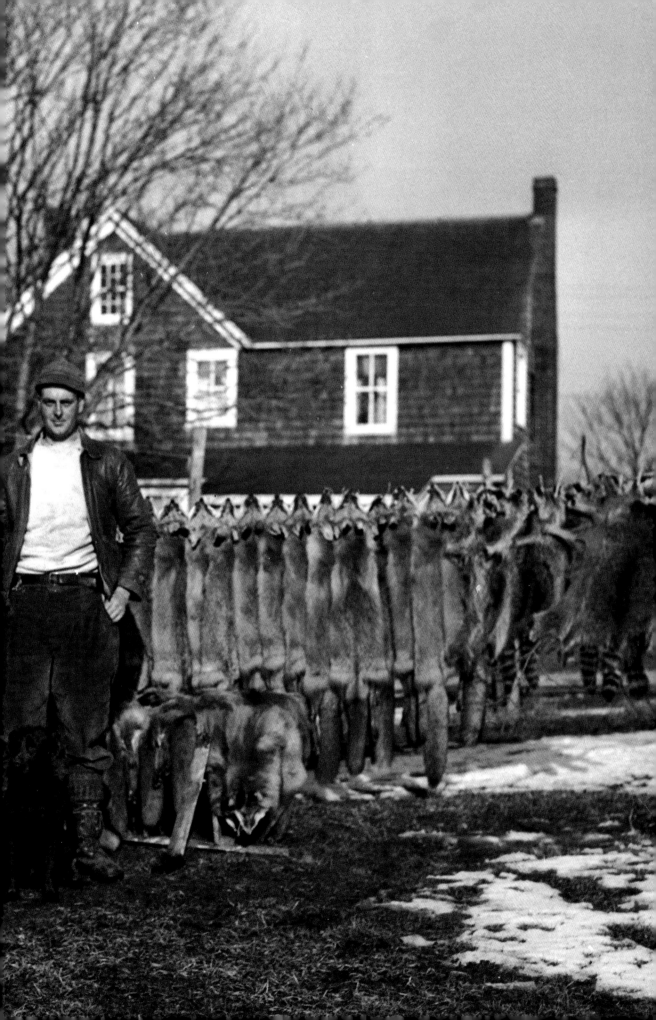

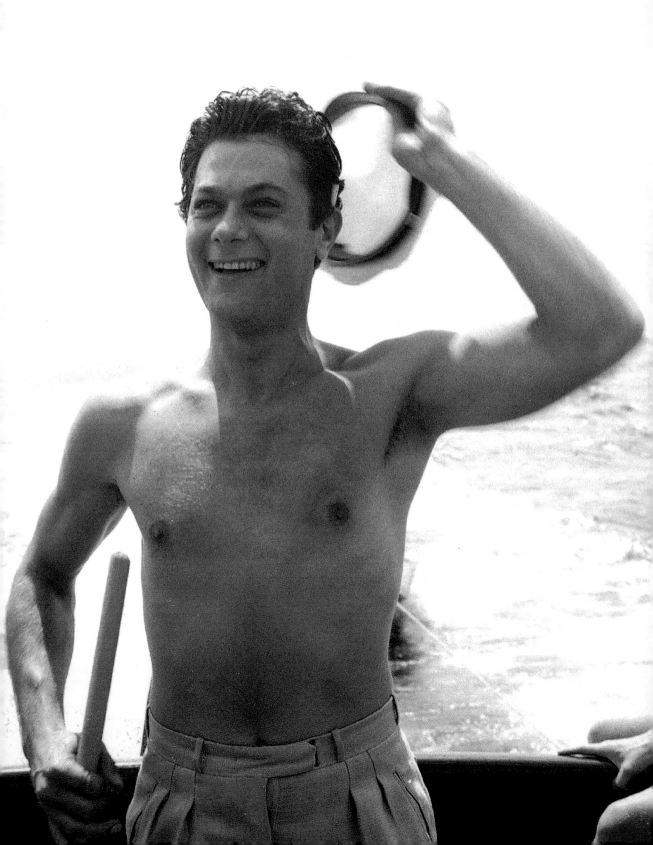

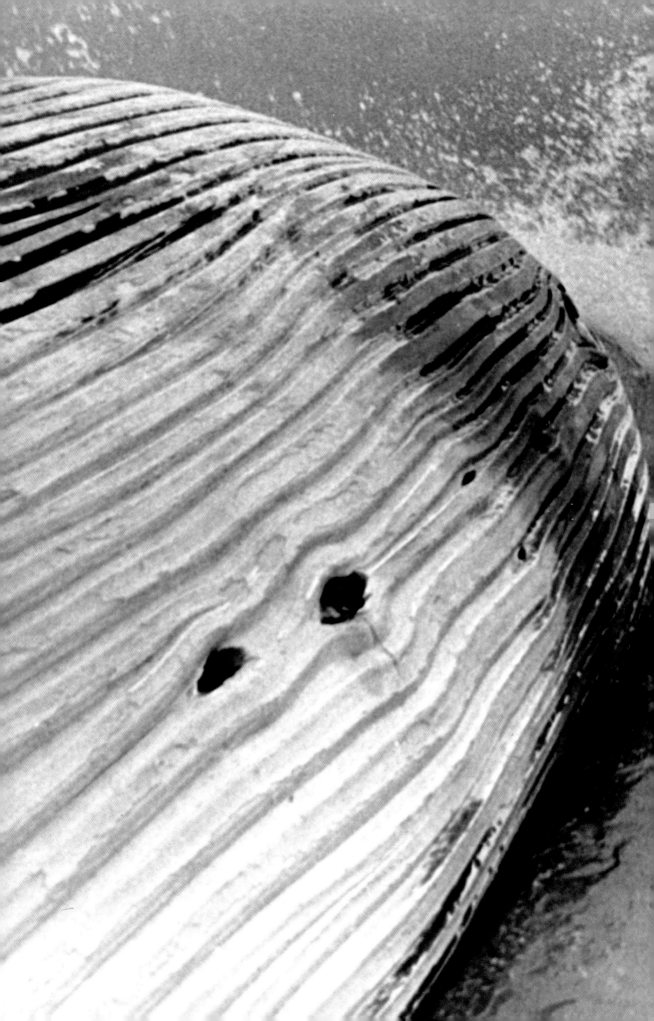

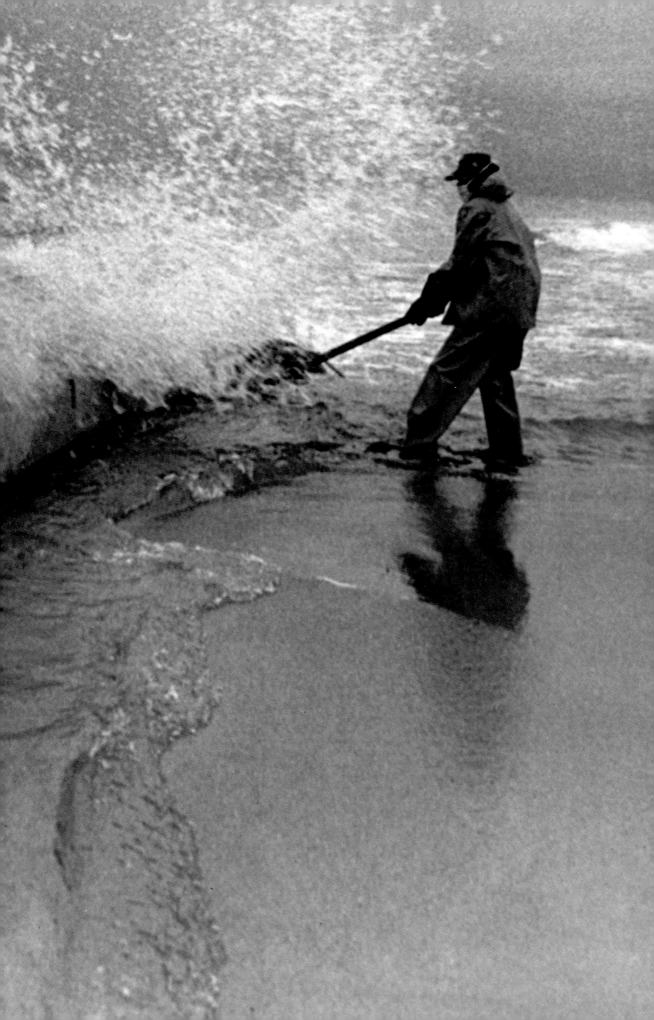

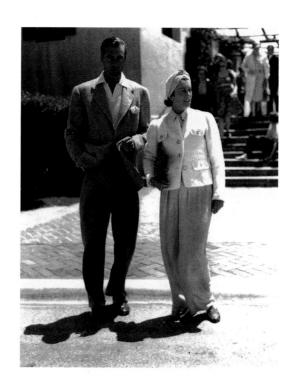

Southampton

Traveling east into the Hamptons on 27-East, the first village one passes through is Southampton. Named in 1641 by Puritan settlers after their original home in England, Southampton still has families in the area who can trace their lineage 16 generations back to those first settlers. In 1648, Thomas Halsey erected his house in Southampton, which still stands in its original location on Ocean Drive off of Main Street and is the oldest house in New York State.

Southampton is the commercial center of the Hamptons and, as such, boasts amenities that the other villages lack—like the only hospital in the Hamptons. The oldest department store in the country, Hildreth's, established in 1842, still resides there. Southampton's two perpendicular main streets are lined with boutiques, antique shops, home shops, a Saks Fifth Avenue, and other upscale stores reminiscent of Palm Beach. Southampton is perhaps best known for its elaborate beach-front summer homes, whose residents play host to some very extravagant charitable parties. For instance, the "diamond lunch," where women are encouraged to wear their best diamonds, and many other parties just perfect for that little shift dress and pair of loafers from Stubbs & Wootens. Southampton

ABOVE *Gary Cooper and wife Sandra Shaw on a road in Southampton in 1940.*

OPPOSITE: *Southampton is well known for its estate homes on the Atlantic Ocean—notorious for its shifting sand dunes. One man spent millions to maintain the dunes in front of his house and the very next day, the man-made dunes were washed away.*

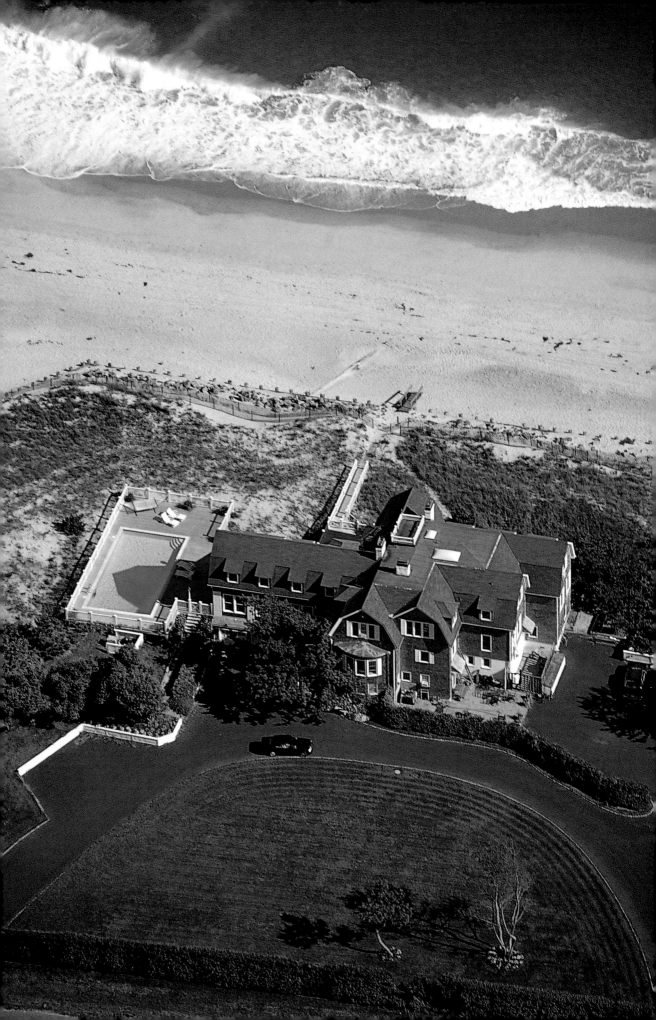

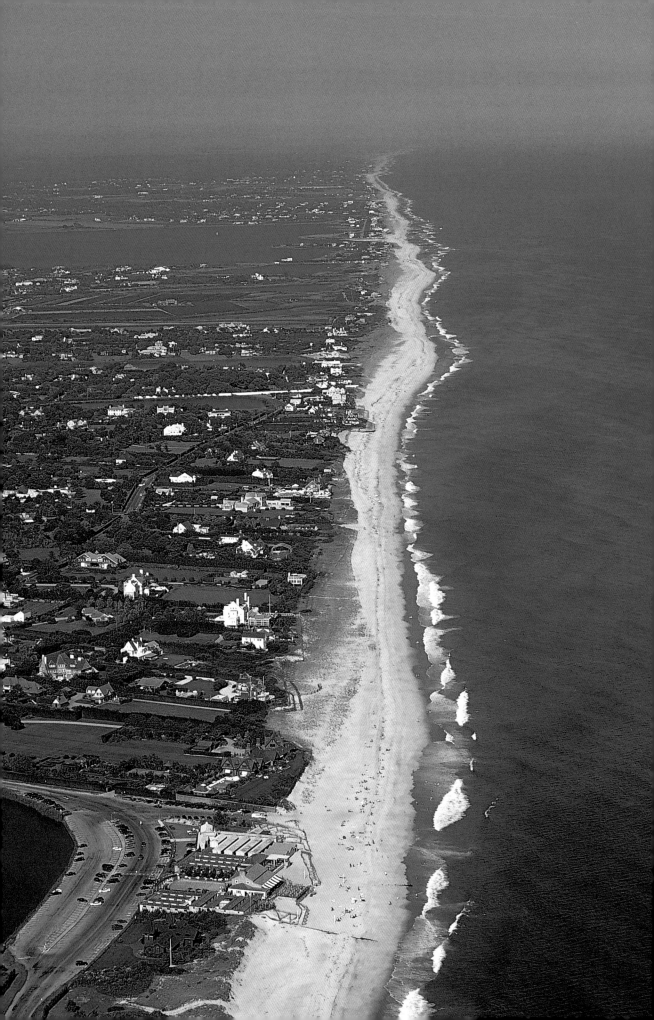

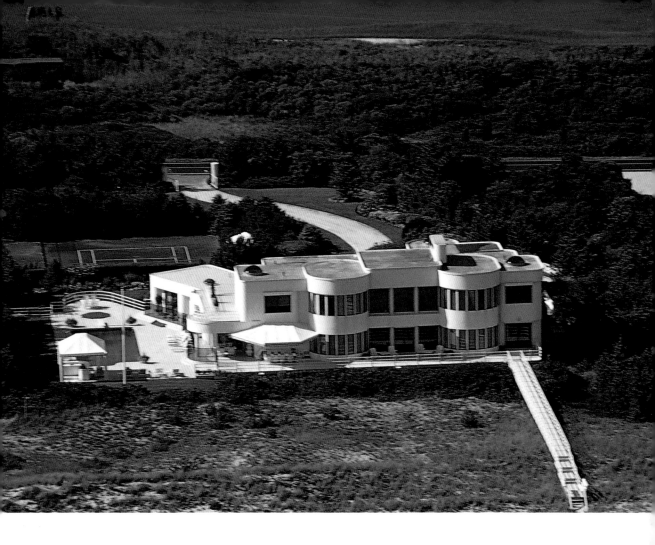

exudes money and residents are known to show it, and spend it, in any way they can.

Although Southampton is known primarily for its lively social scene, it still boasts a formidable cultural climate, the foremost bastion of culture being the Parrish Art Museum. Built at the turn of the century, it has grown from a small village museum to an important venue dedicated to 19th and 20th century American art. This venerable structure is home to works by the likes of American impressionists Childe Hassam, William Merritt Chase, and Thomas Moran, and more avant-garde American artists Lee Krasner, Alfonso Ossorio, Chuck Close, and Robert Rauschenberg, all of whom either resided in, or visited, the Hamptons at one time or another. Parrish's architect, Grosvenor Atterbury, himself a Hamptons native, was born in nearby Shinnecock Hills. Atterbury's other distinguished accomplishments include the American Wing at the Metropolitan Museum of Art and the restoration of New York's City Hall. He also built the Shinnecock Golf Course, which hosted the U.S. Open.

Although several artists of great stature summered there, it was William Merritt Chase who fostered the beginnings of a

ABOVE: *Beach home on Dune Road.*

OPPOSITE: *Partygoers of* El Morocco.

PAGE 50: *A social club exclusively for gentlemen.*

The Southampton Club, Southampton, L. I.

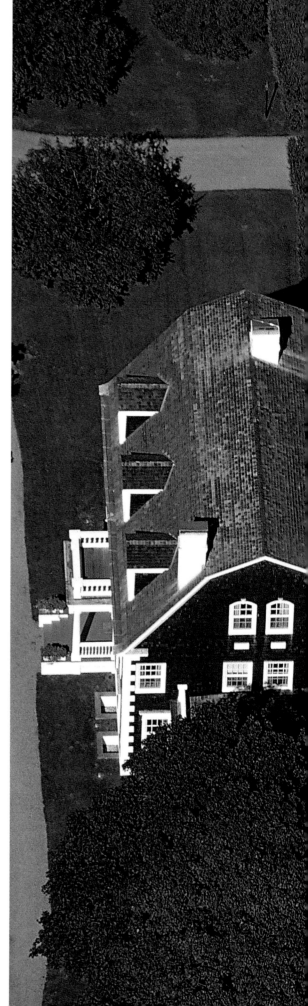

true artists community by establishing, just west of Southampton, the Shinnecock Hills Summer School of Art, the first outdoor school of painting in the country. Although now strictly residential, the area is still known as the Art Village.

Southampton consists of three bays—Shinnecock, Peconic, and Noyac—which border the town and are great for windsurfing and other water sports. Many Hamptons locals joke about the Shinnecock Canal. They say that the Hamptons begin at the Shinnecock Canal and end at Montauk; anything before that, they assert, is just a town. This is a very pointed joke intended to create a psychological boundary between Southampton and the towns off of the Sunrise Highway (27-East) and the rest of Long Island. It is clearly a lore, as the township of Southampton continues all the way west to Eastport. This canal separates the bay from the Atlantic Ocean, due to the Shinnecock Inlet that was created by the hurricane of 1938, and runs through Long Island up to the North Sea (Peconic Bay) and to Sag Harbor. The beaches in Southampton are legendary, and the most famous of these coastal areas is Flying Point Beach, which is known for its lively social scene. The beaches are also notorious for shifting

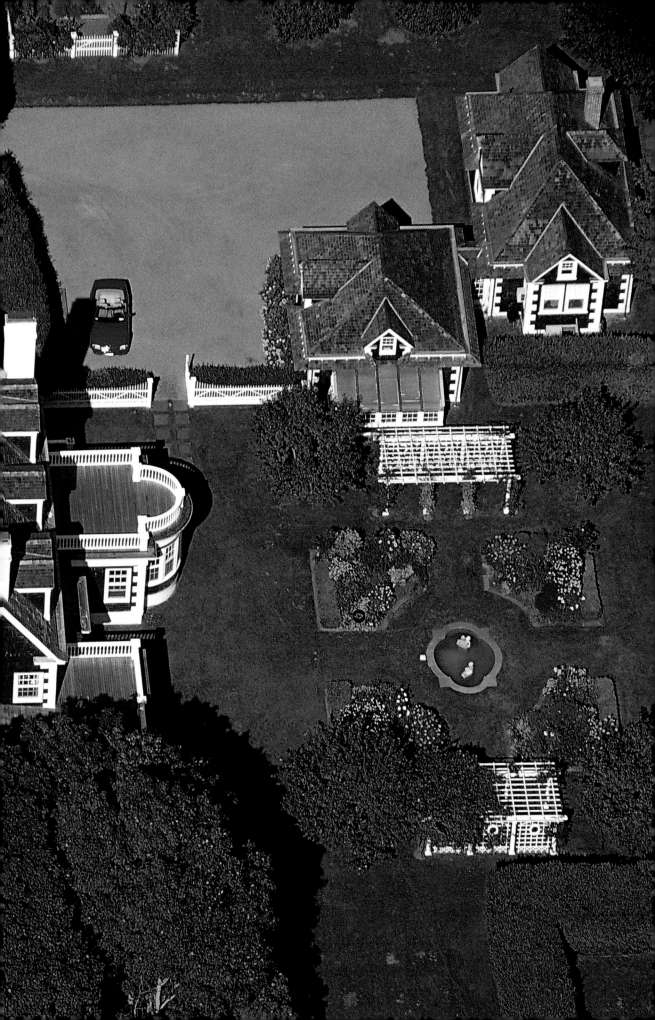

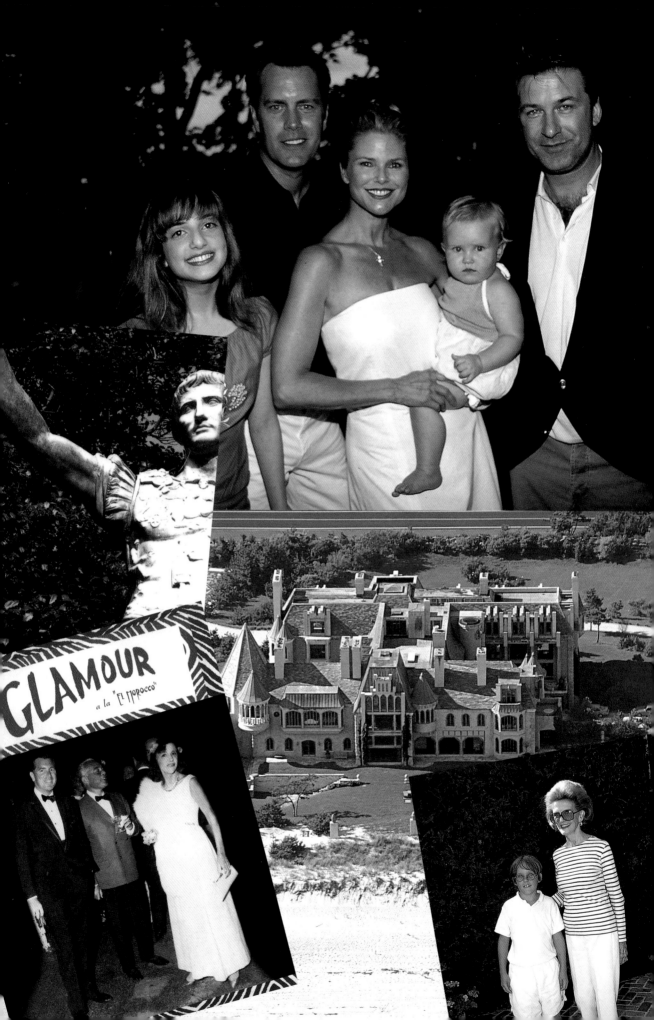

GLAMOUR
a la "El Morocco"

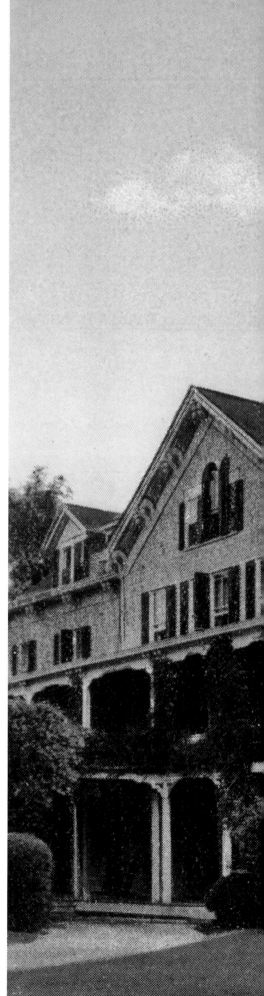

sandbars. One summer, one may have a beach with dunes in front of one's home, the next summer one may have no beach and no dunes.

As with all of the Hamptons, incongruities abound in Southampton. In this exclusive, socially conscious town, one can still get a "greenkey pass" and park one's mobile home there for months. But it is still the mecca of private clubs. If you want to swim at an exclusive private club, you must belong to the Bathing Corporation. If you want to play tennis on grass courts, you must belong to the Meadow Club. And if you want to play golf you can join the Shinnecock Golf Club. This famous course opened in 1891 by Samuel Parrish, and hosted the 1986 U.S. Open.

Southampton has it all: from historical museums and car dealerships to Indian Pow Wows and exclusive clubs. But what makes Southampton so desirable are the underpinnings; the beaches are voluptuous and clean, and the inlets are incredible for watersports or just taking in the landscape—and, of course, the social scene.

ABOVE: *Camping on a Southampton beach.*

OPPOSITE: *A typical turn of the century home with covered balconies wrapping the house.*

The Irving House, Southampton, L.I.

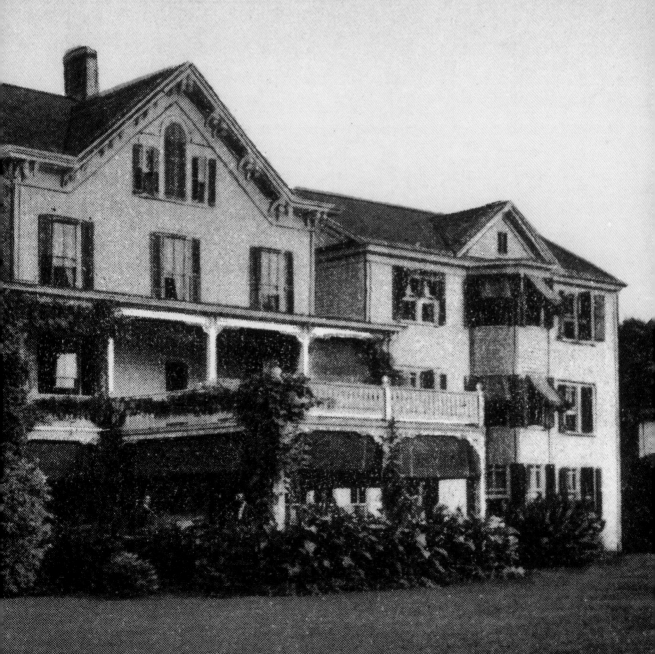

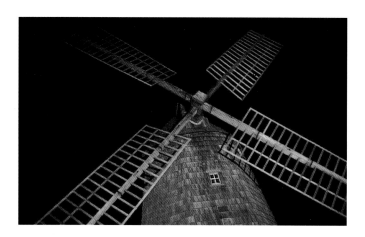

Water Mill

Just east of Southampton lies the village of Water Mill, which originally grew up around a grist mill built in 1644 to accommodate the burgeoning population of Southampton two miles away, and still stands today as the historical focal point of this charming town. People travelled from miles around to mill their grains here for over a hundred years. Now the mill houses a museum, which is a must for those interested in the fascinating history of this region.

Situated between Southampton and Bridgehampton, Water Mill shares many of the same luxuries as its larger neighbors. Homes are magnificent, and space is abundant. The palatial Villa Maria, constructed in 1887 by Manhattan department store magnates Josiah Lombard and Marshall Ayers, occupies some stunning acreage between 27-East and the waterfront. This beautiful estate was a private residence until 1931 when it was transformed into a convent for the Catholic Dominican sisters. In 1980, it also became home to the Sienna Spirituality Center, where at the water's edge, anyone can come for peace and quiet contemplation.

ABOVE: *The village of Water Mill was named after its famous grist mill. The mill, built in 1644, was one of the many landmarks destroyed in the hurricane of 1938. It has since been rebuilt as authentically as possible.*

OPPOSITE: *"The Astronauts," created by integral artist Mihai Popa (aka Nova), are 18-22 feet tall steel structures that stand solemn and still and face mysterious worlds. These sculptures are part of The Ark Project, which consists of sculptures, gardens, a museum, gallery and workshops for young artists.*

"I love the field I look onto, which is part of the Nature Conservancy, and the changing quality of the light as the sun reflects off the field.**"**
Richard Meier

PAGES 58-59: *This typical shingle style home, built in 1885, was the Master House of the region. Lands were divided later for farming and other residences.*

ABOVE: *A home in Water Mill on Cal's Creek (part of the old Mecox Bay area). Water Mill is one of the quaintest villages in the Hamptons—directly off 27 East, it includes personal residences, farmland, a post office, a deli, antique shops and local fresh produce stand.*

OPPOSITE: *Directly off of 27-East in the center of town, is Villa Santa Maria. Built in 1887 by Josiah Lombard and Marshall Ayers, it has been a convent and, more recently, a spirituality center. The Villa's sprawling lawn has played host to a few charity events.*

Water Mill, like the other Hamptons, has its share of artists and artistic forums where one can see, participate in and learn about the arts. Robert Wilson, world renowned director/playwright/designer/innovator has lived there for many years and recently opened the Water Mill Center, where people from all walks of life may visit to learn about and experience the arts and humanities.

Nurseries and small family-run stores selling everything from pool supplies, pianos and hockey equipment line 27-East as it passes through town. Although one of the smallest villages in the Hamptons, Water Mill has one of the best delis (called, incidentally, The Deli) tucked away between a candy store and an antiques store. It is now a common stop for those gastronomically inclined. In addition New York's Citarella recently opened a branch there. Look carefully and you might see Sarah Jessica Parker loading her cart—she and her husband, Matthew Broderick, just bought a home there.

ABOVE: *Writers and friends of James Jones met at Gloria Jones' home for the premier of Kali Jones' film* A Soldier's Daughter Never Cries. *Left to right, standing: E.L. Doctorow, Ishmail Merchant, (back) Peter Matthiessen, Kurt Vonnegut, Kris Kristofferson, Norman Mailer, James Ivory, Arthur Miller. Left to right, in hammock: Ruth, Prawer-Jhabala, actor from the movie, Kali Jones, William Styron, Gloria Jones, Elaine Kaufman, Alan Pakula.*

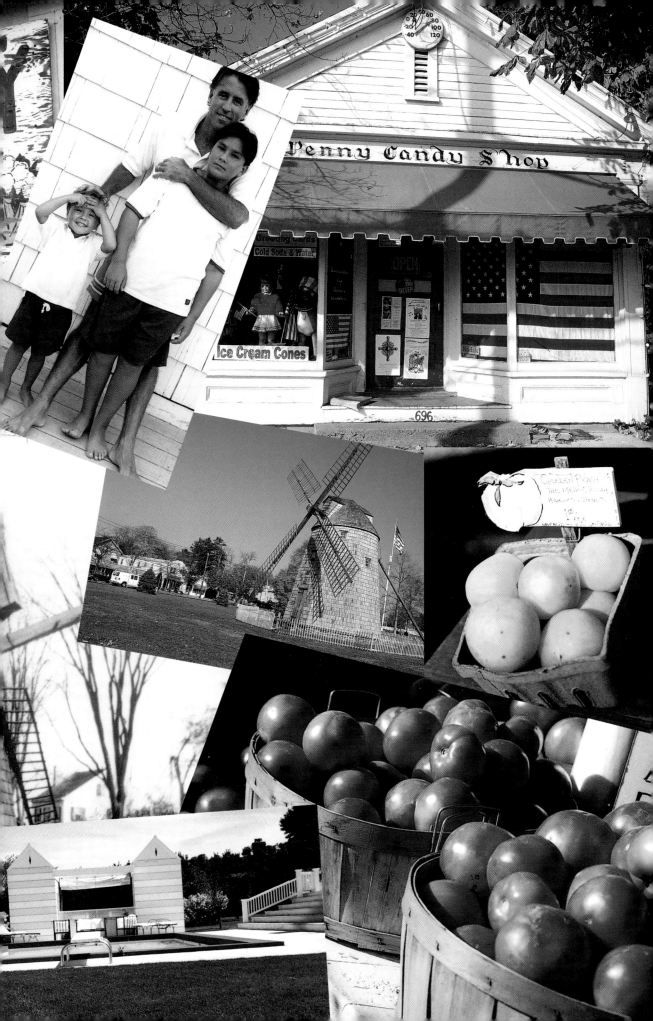

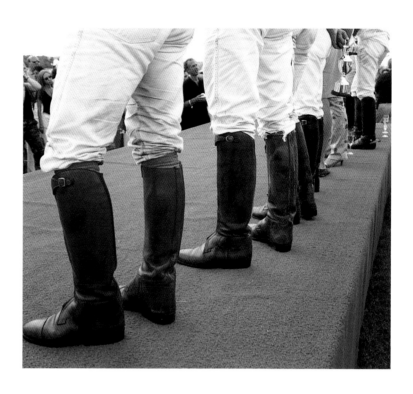

Bridgehampton

ABOVE: *Mercedes Benz Polo Challenge awards ceremony, part of the Bridgehampton Polo Tournament held on Two Trees Stables property.*

OPPOSITE: *The Hampton Classic was first organized in Southampton in the early 1900s, and was discontinued, due to wars and hurricanes, until its revival at the Topping Club in Sagaponack. It is currently held on Snake Hollow Road in Bridgehampton. With more than 1,300 horses exhibited and over $500,000 in prize money, it is a show from any angle: celebrity riders, guests and sponsors such as* Town & Country, Vogue, *and* People *magazines feature it.*

Bridgehampton, named for a bridge constructed by settlers to join the Sagg and Mecox areas over Sagg pond, is the next stop on our journey. Settled in in 1656 by Josiah Stanborough, one of the seven English settlers who arrived at Conscience Point, Southampton in the 1600s, Bridgehampton is still known as "hayground" for its vast fields of hay grass, farmland, and horse farms. It is also the home of the Hampton Classic, one of the most prestigious horse shows on the East Coast, first held at the Topping Riding Club. The Classic plays host to the largest outdoor hunter-jumper horse show in America, with events designed specifically for those inclined toward Grand Prix jumping.

North of the highway, on Hayground Road, one can also enjoy the Mercedes Benz Polo Challenge, a series of polo matches held every Saturday from the end of July to the beginning of August. Although other polo matches are held on Sundays, the weekly Saturday games, sponsored by Mercedes Benz, are usually associated with charity cocktail parties. Everybody who is anybody either has a tent, is tailgating, or attending the cocktail party under the tent.

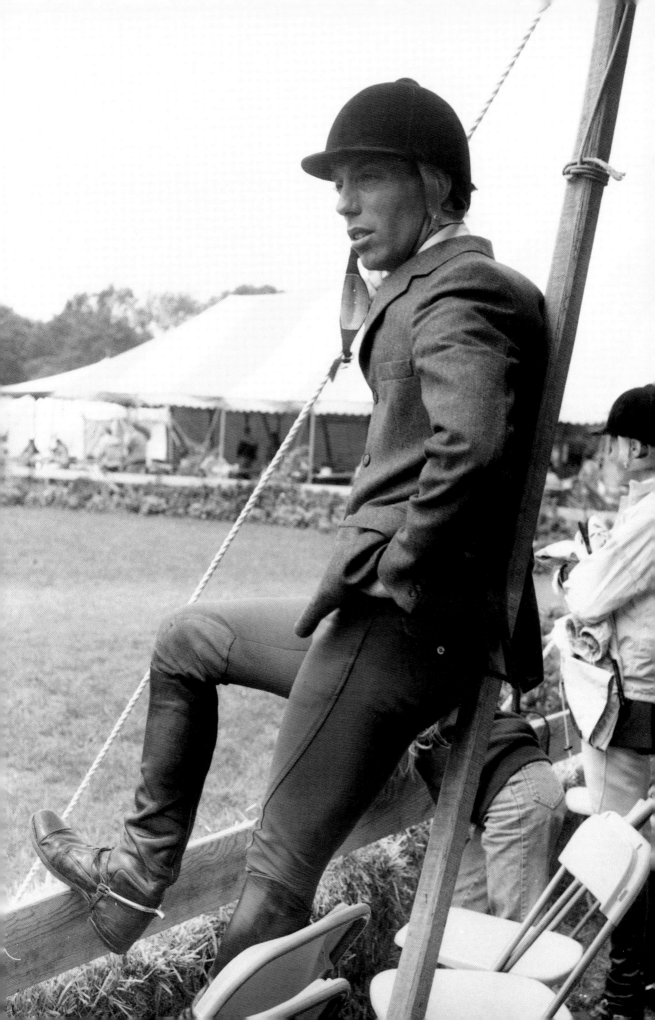

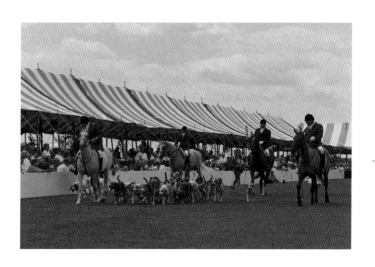

Billy Baldwin, Elizabeth Hurley, Rene Russo, among other notables and celebrities, have been photographed there more than once. Those who love the game watch the horses switch from canter lead to canter lead in a matter of seconds. The muscles of the horses and the agility of the Argentinian polo players are magnetic. Sweat. Heat. Muscles. Shaved manes. Wrapped tails. Cocktails. Wide brimmed hats. It is an event from any angle.

Interspersed with manicured horse farms, one finds innovative modern architecture and beautiful landscapes in Bridgehampton. It is the home of *Dan's Papers*, King Kullen, American antique stores, the Candy Kitchen restaurant—where people line up for breakfast—and Bobby Van's restaurant, which is known for its artist and writer clientele. Directly behind the polo fields and Two Trees stables, sits someone's personal golf course. Directly across the street from that is the private golf club, The Atlantic. Right next to the Atlantic, there is a field that is filled with the most gorgeous wildflowers with a beauty capable of taking your breath away. And, right up the street, are the most verdant trees at Oceanaire nurseries. It is as though they are always smiling. They are the most plush evergreens, the whitest white birches, and Japanese maples, whose branches intertwine in a way that looks poetic.

Bridgehampton is the backbone of the Hamptons, connecting the east with the west. Every major equestrian event is held there and every major show barn is situated there. If you do not like riding, you can go there to see some of the most unusual landscapes and magnificent patches of wildflowers anywhere.

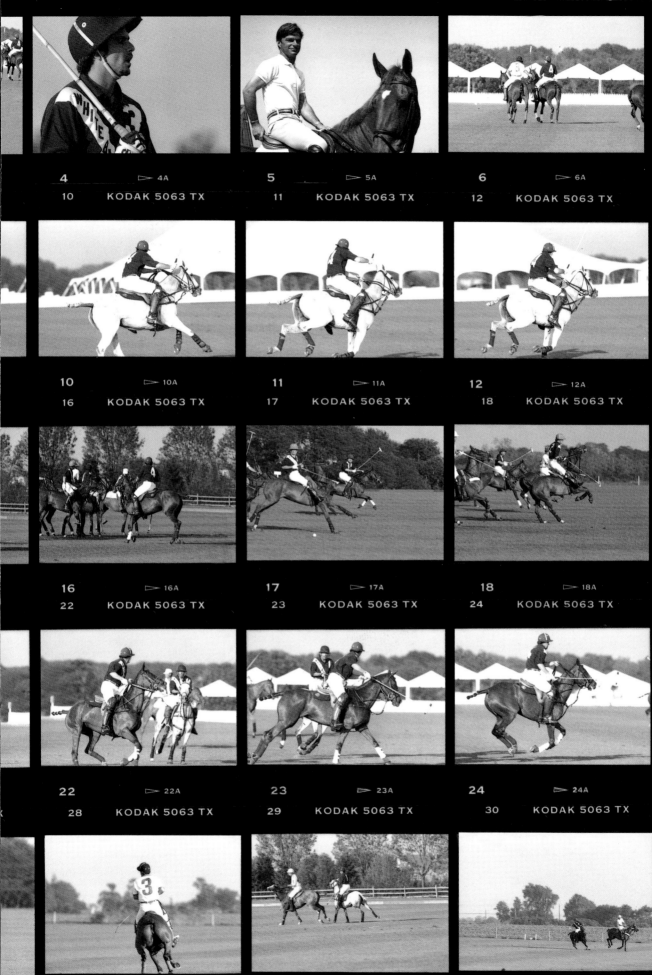

4 ▷ 4A 5 ▷ 5A 6 ▷ 6A

10 KODAK 5063 TX 11 KODAK 5063 TX 12 KODAK 5063 TX

10 ▷ 10A 11 ▷ 11A 12 ▷ 12A

16 KODAK 5063 TX 17 KODAK 5063 TX 18 KODAK 5063 TX

16 ▷ 16A 17 ▷ 17A 18 ▷ 18A

22 KODAK 5063 TX 23 KODAK 5063 TX 24 KODAK 5063 TX

22 ▷ 22A 23 ▷ 23A 24 ▷ 24A

28 KODAK 5063 TX 29 KODAK 5063 TX 30 KODAK 5063 TX

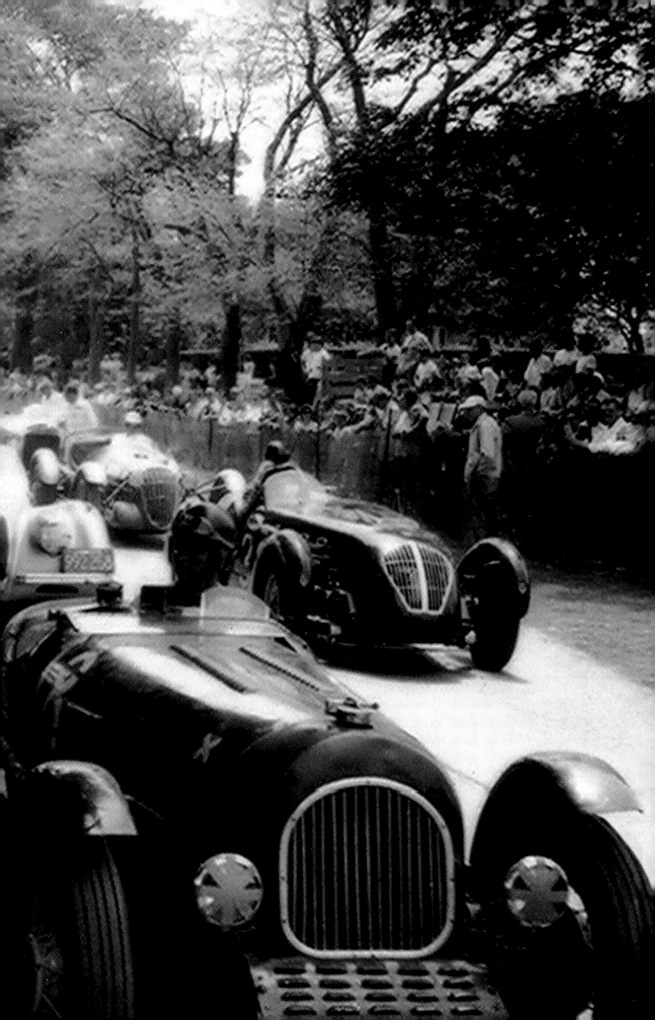

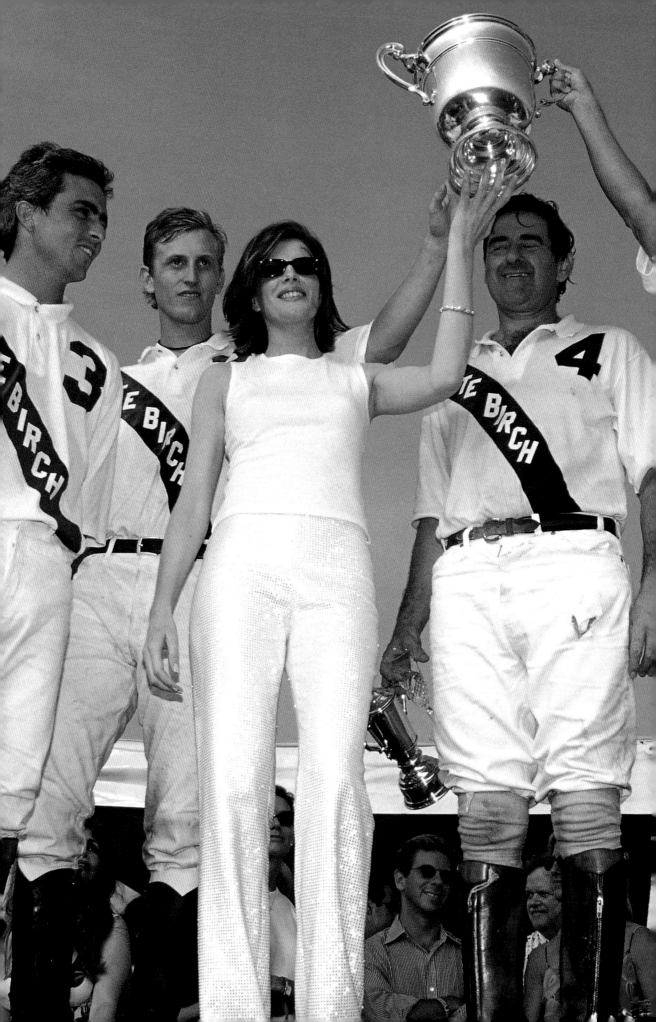

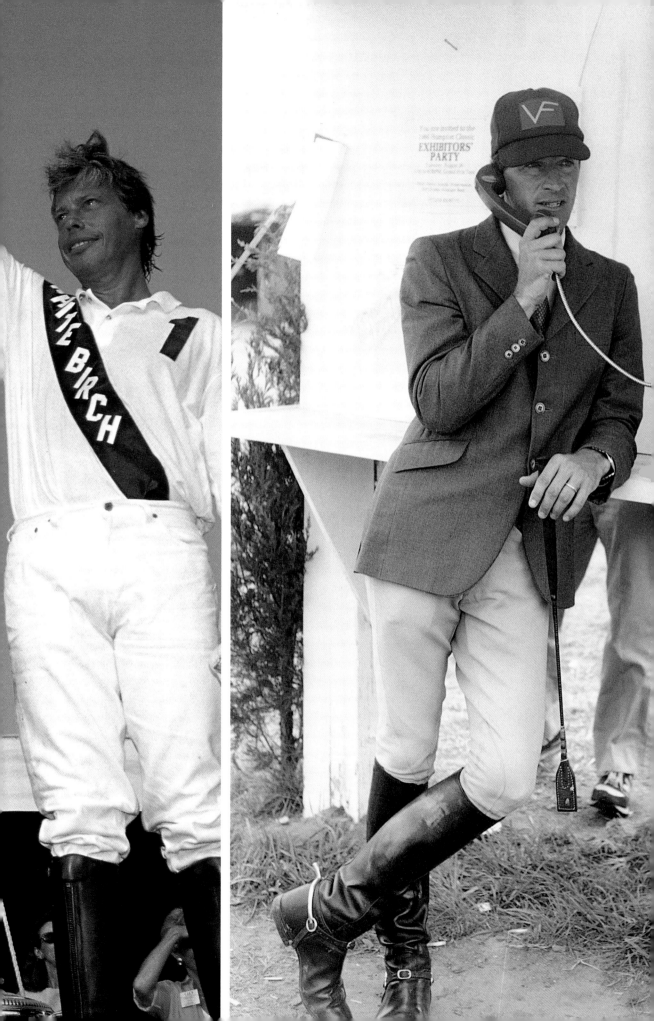

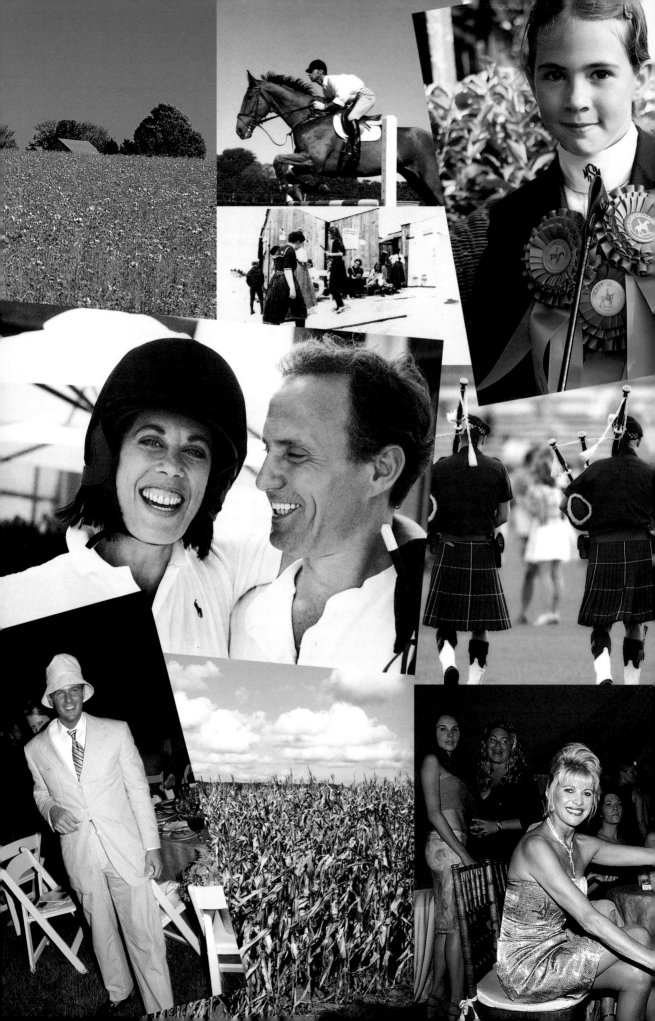

Sag Harbor

Directly behind Bridgehampton is the village of Sag Harbor. Located on the bay side of Long Island, it is easy to access via the Sag Harbor Turnpike, which runs perpendicular to 27-East. The Native Americans who inhabited the area called the place Weg-wag-onuch, or "land at the edge of the hill," but the topography has changed much, and the land-at-the-edge-of-the-hill is now one of the most interesting villages, architecturally speaking, in all the Hamptons.

The once sleepy town of Sag Harbor came to prominence during the whaling boom of the mid-18th century and was declared a major port of entry on July 31, 1789 by decree of George Washington. As one of the three most important whaling ports in the world, Sag Harbor had more tons of square-rigged vessels engaged in commerce than its famous rival port of New York City, and between 1816 and 1837—a period known as the golden years of whaling—enjoyed a prosperity not seen before or since.

The population of Sag Harbor grew dramatically in a short time with an influx of people from ports as far flung as Brazil and China. This gave Sag Harbor a cosmopolitan atmosphere and a sophistication that is still evident today. For sheer variety,

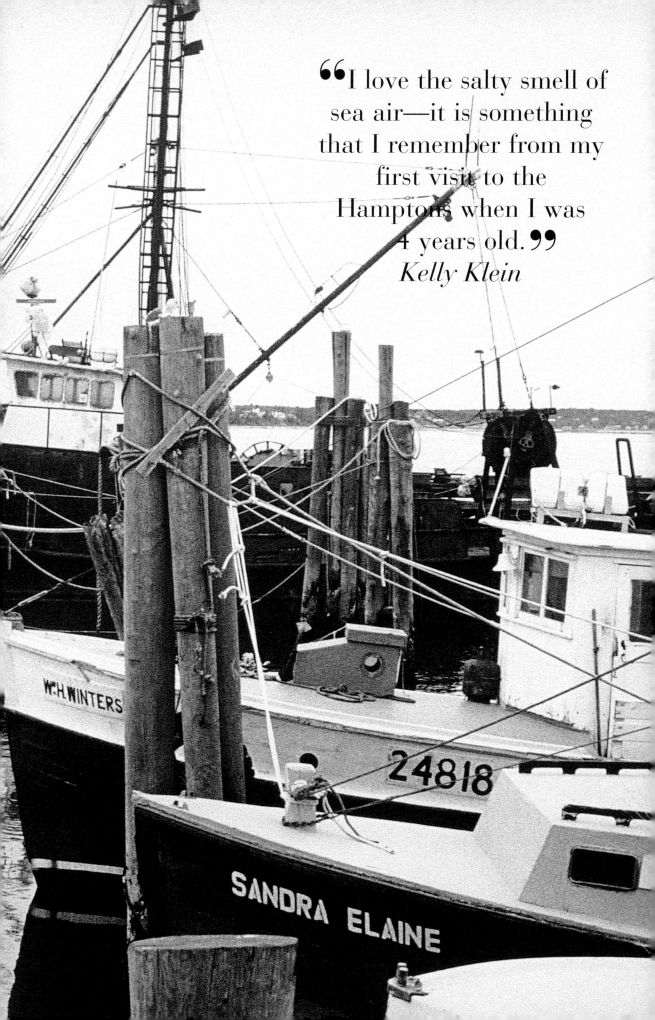

"I love the salty smell of sea air—it is something that I remember from my first visit to the Hamptons when I was 4 years old.**"**
Kelly Klein

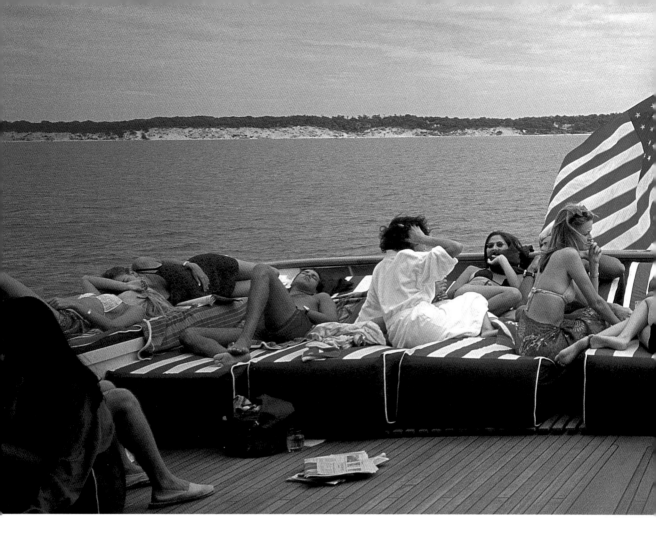

its architecture cannot be rivaled by any other town in the Hamptons; the contrast between rural village and international port is still distinctly evident—the monumental sits side-by-side with more humble dwellings and the tiny streets intertwine among eclectic homes and buildings. The main street resembles a quiet fishermen's village filled with American antique shops, souvenir stands, nautical supplies, and some of the best ice cream around. The village homes and public buildings run the gamut from Colonial to Egyptian Revival to High Victorian.

Sag Harbor's remaining Colonial-style homes with their spare symmetry, were built by the first English settlers who adapted British styles to the new world in what was to become the true early-American style. After the whaling and shipping industries brought new prosperity to the area, more florid, elegant styles came into vogue reflecting the residents' desire to spend some of their riches. In 1825, Greek Revival typified the architectural trend in America, and its elegant lines and classical motifs are evident in many of Sag Harbor's more prominent structures, including the Masonic Temple and

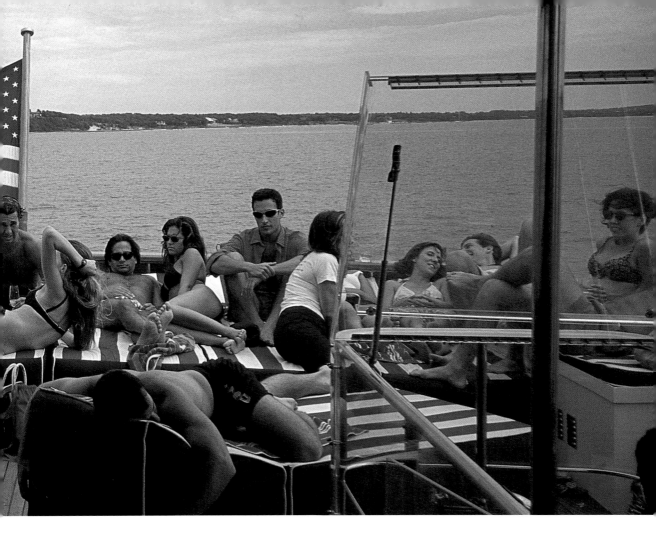

Whaler's Presbyterian Church. The Gothic Revival style—"invented" by American architect Alexander Jackson Davis who championed the quasi-romantic ideal of harmonizing nature and the domestic—characterizes the Municipal Building and the American Hotel.

After the collapse of the whaling industry in the 1860s, and a relatively quiet period on the East End, came the affluent vacationers who began the transformation of the Hamptons into what they are today. Boarding houses were fine for a few seasons, but the gentry eventually desired their own summer residences and began to snap up some spectacular properties for their vacation homes. Many of those homes were built in the Early and High Victorian period that bridged the late 19th and early 20th centuries. The Napier Howell House, Hannibal French House, and Ephraim Bryan House, are just a few examples of this whimsical period in architecture.

These days, tourists come not only for the wonderful eclecticism and charm of Sag Harbor, but for its shops and mansion-like yachts.

ABOVE: *During the summer, the quiet village of Sag Harbor is home to more yachts with more staff in its harbor than typical homes in the village.*

> **"**There is something about the beach and the light in the Hamptons that I have found nowhere else. **"**
> *Calvin Klein*

SAG HARBOR

Sagaponack

Tucked away between Bridgehampton and Wainscott lies Sagaponack—meaning "land of great ground nuts" (potatoes in Indian parlance). Among the many grand homes, large potato farms, and pumpkin patches are some Hamptons favorites, including: Sag Pond Farm and Vineyards; Loaves and Fishes—a catering mecca among Hamptonites, the Old Stove Pub restaurant, antique stores, the Sag Store (where the mail is delivered) and Topping Riding Club.

Among horse farms, Sagaponack has one of America's dwindling one-room schoolhouses still functioning.

A very large, waist-deep pond running through Sagaponack into the ocean separated Bridgehampton from Sagaponack until a bridge was built.

The pond is filled with picturesque sea grasses and various water fowl—a dream spot for those who love to canoe.

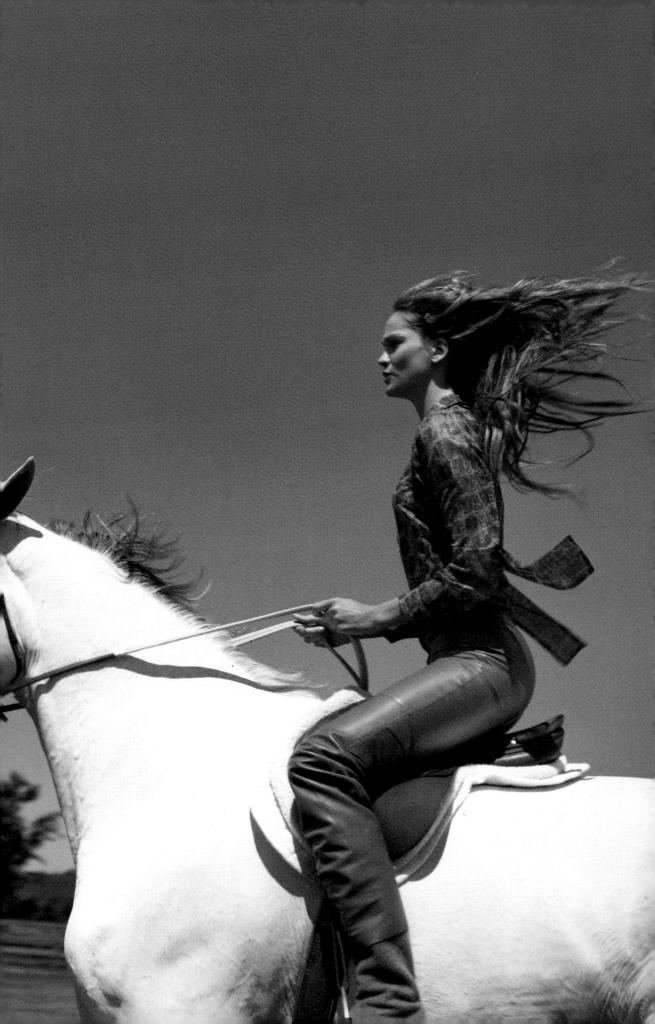

66 The country is my sanctuary—
the perfect place to be with my family
and friends. **99**
Aerin Lauder

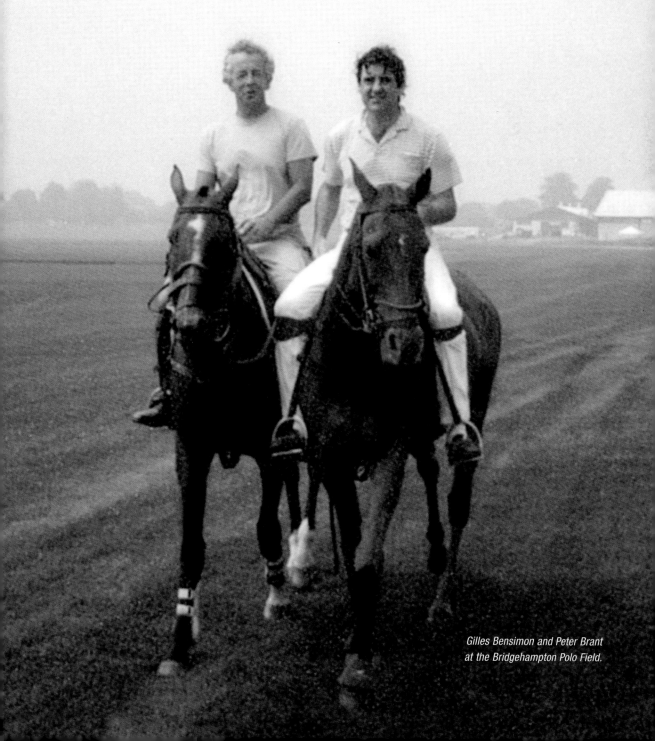

"If you weren't part of a community, it could be very lonely. Every day, after I was finished writing, I used to drive around to look at the beautiful open vistas."
Steven Gaines

*Gilles Bensimon and Peter Brant
at the Bridgehampton Polo Field.*

Old Stove Pub

Shelter Island

To get to Shelter Island, situated in the bay between the North and South Forks of Long Island, you must take Route 114, which runs straight through the island, to either the South Shore or the North Shore ferries. Both will take you directly to the island, named "Manhansack-aha-quash-awomack" (island sheltered by islands), by the Indians who first lived there before it was settled by sugar merchant Nathaniel Sylvester, in the mid-1600s. Then, it was purchased from the Manhasset Indians by Sylvester and four other sugar merchants for 1,600 pounds of Barbados sugar. It is said that the island was known as a retreat for various religious groups, such as the Methodists, Presbyterians and Quakers, who came there seeking the freedom to practice their respective religions in peace.

And peace is something one finds in abundance on this island. Although locals are fond of saying that the best thing about Shelter Island is the ferry and the worst thing about the island is the ferry, one thing is for sure: the only way one can get to the island is to take the ferry, due to the fierce currents. Ferries run about every ten minutes from as early as 6 A.M. and run up until 1 A.M. But it hasn't always been this way. In

ABOVE: *Captain Bill Clark overlooks his ferry service, which has been in his family for six generations.*

OPPOSITE: *A view from Shelter Island sound to Shelter Island, the "Un-Hamptons."*

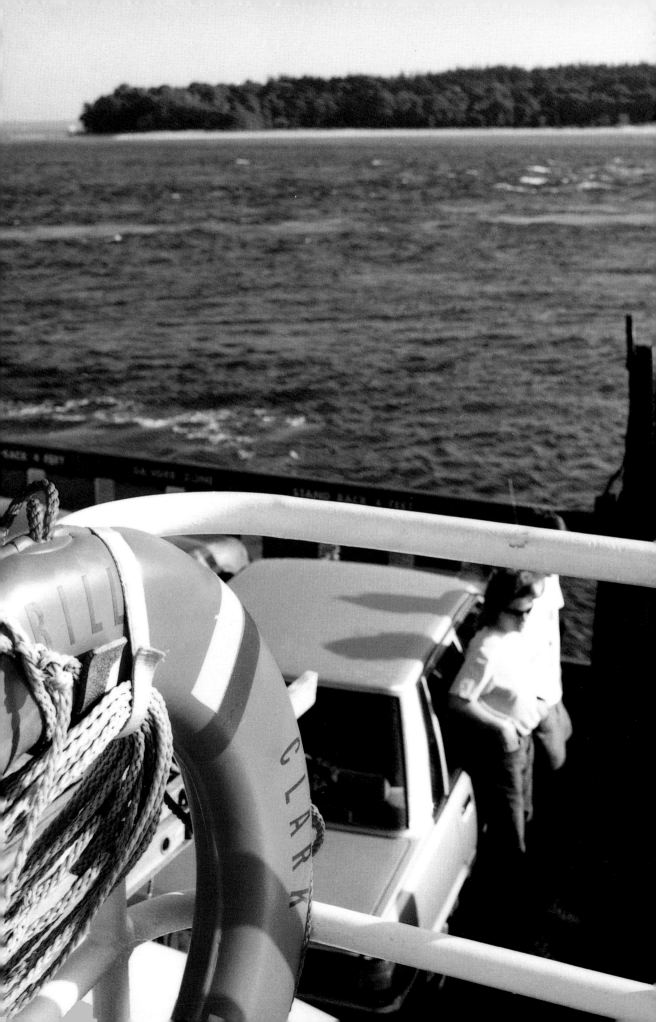

the 1950s, there were only two wooden boats that held seven cars travelling to the South Fork once a day. In 2001, there are four ferries—the smallest holding nine cars, the largest 19. But despite its relative accessibility, this little island (its shoreline is only 40 miles around) is still largely unspoiled and is known as a spectacularly beautiful resort community with lovely winding roads, several grand hotels, a large golf course, charming gingerbread cottages, and literally breathtaking landscapes.

Although surrounded by saltwater, the island is unusual in that there are two large fresh water lakes with large-mouth bass and other fresh water fish. At low tide there is also an abundance of shellfish. However, the main source of income for the island, apart from tourism, was farming lima beans.

Its beauty and seclusion are two reasons why locals have struggled to keep the island true to its name, and indeed East Enders refer to Shelter Island the land of "no"; its zoning board being notoriously strict in order to preserve the island's natural habitat. The Nature Conservancy bought a third of the island (called the Mashomack Nature Preserve) in order to

ABOVE: *View of Sunset Beach Hotel on Crescent Beach in Shelter Island.*

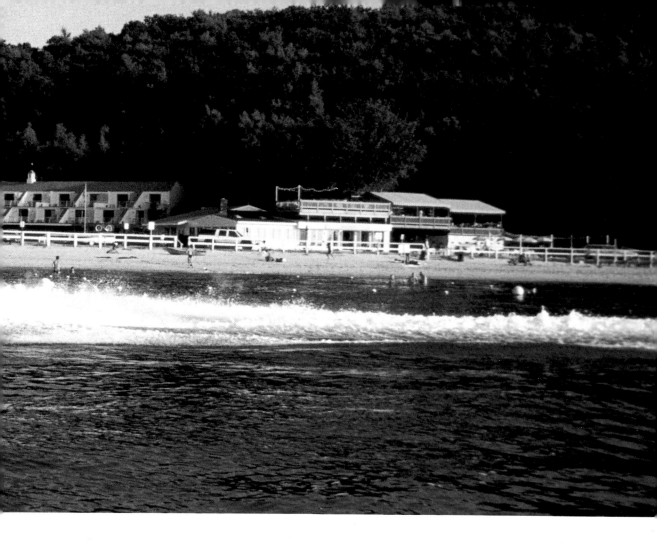

ensure that it remain intact. The nature preserve and Morton Wildlife Park are open to anyone who wants to wander through these lovely, unspoiled landscapes for bird watching or just for quiet enjoyment.

But its self-sufficiency does not end there. The center of town has its own hardware store, department store, pharmacy, and village market. And for leisure, there is a riding stable, golf links, and a regatta—which has taken place at the Shelter Island Yacht Club since the 1930s. There is even a newspaper, the Shelter Island Reporter.

In keeping with the East End's reputation as a harbor for all things artistic, violinist Itzhak Perlman opened a school for gifted musicians there. And there are some great restaurants too; entrepreneur Andre Balazs bought the 1950s-style restaurant and hotel called Sunset Beach which serves the best mussels in the Hamptons.

Shelter Island is neither part of the Southampton township, nor the East Hampton township. Rather it is directly connected to Suffolk County and has no responsibilities to the Hamptons. It remains one of the Hampton's best kept secrets.

Capt. BILL CLARK

The South Ferry
TO SHELTER ISLAND
749-1200 • 749-1201
Sun. Thru Thurs.: 6:05 A.M. – 11:45 P.M.
Fri. & Sat.: 6:05 A.M. – 1:50 A.M.
RATES
1 WAY ROUND TRIP
CAR & DRIVER
PASSENGERS 7.00 8.00
MOTORBIKES 15YRS & OLDER 5.00 2.00
BICYCLES 3.00 6.00
BUSES 40.00 4.00
 55.00
TRUCKS 20 AND OVER BY LENGTH AND TYPE / MULTI TRIP DISCOUNTS AVAILABLE ON BOATS

East Hampton

When you reach East Hampton, you know it right away—100-year-old elm trees canopy its main street, and a magnificent white Colonial home guards the "gates" to the village like a majestic landmark sentry. Although its meticulously maintained exterior and gardens make the house seem fit for a town squire, or the mayor, strangely enough, it is not inhabited. According to local heresy, the zoning board will not let the owner live there due to building delinquencies.

The owner of the Red Horse Market, a charming store on Route 27, decorates the sidewalk in front with cheerily carved pumpkins and is promptly arrested. Cars on Main Street cannot parallel park here. You will not find colorful signs advertising cottages for rent. And no bike riding or skate boarding is allowed.

These scenarios give some idea of the continuous struggle between those wishing to preserve the original flavor of this unique place (like the formidable Ladies Village Improvement Society) against newcomers who, understandably, want a piece of it and have the considerable means to get it. This is a town whose old-time inhabitants strive to keep things as they were 100 years ago, where there are still

The Township of East Hampton begins at Townline Road at the end of Sagaponack and extends to Montauk. Originally named after Maidstone, Kent, by its Puritan settlers in 1649, East Hampton attracts the Old Guard, artists, celebrities, writers, designers, and wealthy financiers.

ABOVE: *East Hampton Township lifeguards. A word to the wise: Always approach a wave directly and dive through it as deeply as you can. If you are in a riptide, swim parallel to the beach.*

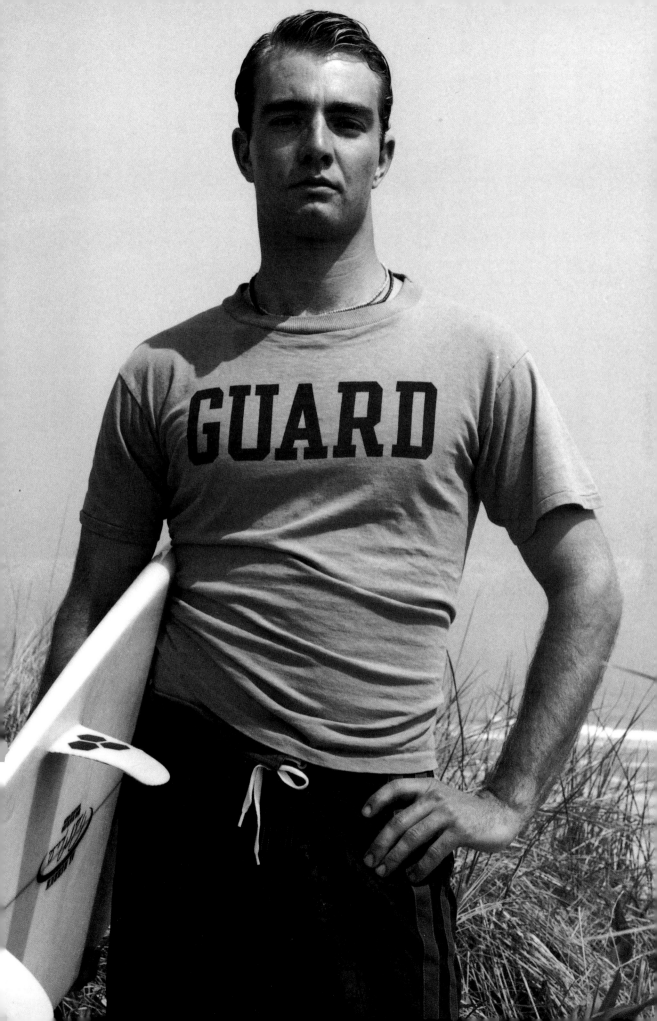

> **"**The Hamptons is where I'm the most truly myself. There is a freedom and an openness. I get to spend time with my family and friends, and I get to live with the beauty of nature—the water, sky, sand, rocks.**"**
> *Donna Karan*

no food chains, and where the construction of new motels is now strictly prohibited. It is also a town where Steven Spielberg and his wife live in a multi-million dollar home and enjoy their own private dressage ring. It is where some of the most wealthy celebrities and artists buy fresh produce from nearby farmers who still make their living off the land, and local fishermen bring in the catch of the day. In other words, it is the contrasts of East Hampton that make it wonderful, if maddening.

But it has always been that way. East Hampton or "Maidstone" was settled in 1649 by Puritan settlers who named the town after their original home in Maidstone, Kent. The purchase of East Hampton was made on April 29, 1648 from the reluctant Montauk tribe for 20 coats, 24 looking glasses, 24 hoes, 24 knives, and 100 tiny wampum drills (used to make wampum, the Indian shell currency). The original settlers were pleased with the price, but now it takes a good deal more than that to own an acre of land. Since East Hampton was "discovered" by well-to-do vacationers in the late 19th century who loved its wide, grassy streets, its pond with swans and geese, and its old world mystique, its appeal has never abated, making it one of the most exclusive communities in the country, if not the world.

It was in 1878 that the artists who would shape the nature of East Hampton life began their pilgrimage. The Tile

ABOVE: *After September 11th, 2001, a proud display of patriotism.*

OPPOSITE: *Donna Karan's sanctuary in East Hampton*

Club, a sophisticated fraternity of painters that included the likes of Winslow Homer, John Twachtman, Childe Hassam, and Thomas Moran, were among the first to come. Written about in a *Scribner's* article in 1878, members of The Tile Club were portrayed as bons vivants dressed up in elaborate suits and hats while painting, thus setting a trend that sealed the fate of East Hampton as a refuge for Manhattan artists seeking old-world charm and natural vistas, without having to travel to Europe. In the 1880s, Thomas Moran and his wife Mary Nimmo Moran, also an artist, built the first permanent artist's studio in East Hampton. According to *Philistines at the Hedgerow* author Steven Gaines, there were so many artists painting in the fields that farmers had to move easels off the land in order to till it.

In 1931, Guild Hall, the art museum located on the corner of Main Street and Dunemere, was opened by philanthropist Mrs. Lorenzo Woodhouse. The newly restored Guild Hall became a community forum for all artistic pursuits, including art classes, gallery shows, concerts, and plays. Some of the writers who have read there include Sag Harbor's

LEFT TO RIGHT: *Perle Fine in her Springs Studio in 1972. David Salle in his Bridgehampton studio.*

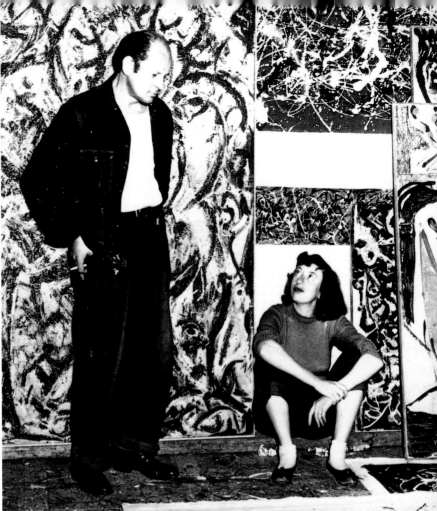

ABOVE RIGHT: *Abstract expressionist Jackson Pollock and wife Lee Krasner. Many artists gravitated to East Hampton because of the clarity of the light. During World War II, and throughout the 1940s, Peggy Guggenheim and surrealist Max Ernst came to East Hampton and brought many of their friends. Shortly after, Guggenheim began supporting Pollock's work, and he and Krasner moved to Springs in East Hampton, where he began to create the works for which he is most famous.*

own Spalding Gray, playwright Wendy Wasserstein and George Plimpton.

Paul Brach, artist and founder of the California Institute of the Arts, attributes part of the artists' romance with East Hampton to its ethereal light. The clarity, intensity and shimmering quality of the light so difficult to describe, yet so beguiling to painters, was certainly remarked upon time and again, as was its peace and quiet so necessary to the contemplative life.

But if solitude and contemplation happened in the studio, outside the studio was another thing altogether. Between the wars and after, wealthy bohemian couples like Adele and Albert Herter, and later, Sara and Gerald Murphy on huge estates provided the setting for artists to gather together as artists love to do. European artists seeking refuge from the wars and following their American counterparts, gathered at these estates and gleefully scandalized their stodgy neighbors. Brach notes that "artists are like sheep," in that they tend to prefer each other's company and follow one another to places where they can work and play together.

ABOVE: *East Hampton attracted the wealthy, but not the pretentious. The estates are vast, but the owners are modest; just like the beautiful colonial home that welcomes visitors with its pristine appeal and immaculate garden. The swans in the town pond are like the homes, beautiful and perfect. But do not come too close—they may bite!*

OPPOSITE: *Self portrait, Chuck Close*

Another major movement to hit the Hamptons in the 1940s was surrealism, which was introduced by Max Ernst, with then wife Peggy Guggenheim, who summered there. Fernand Léger, Salvador Dalí, and even Marcel Duchamp visited at one time or another.

Then came the abstract expressionists led by Jackson Pollock and his wife Lee Krasner. With Guggenheim's patronage, the couple was able to buy their home in the nearby Springs. Pollock's interest in sand painting and American Indians no doubt fueled his interest in East Hampton, and the solitude and luminous light—along with his removal from Manhattan's bars—were necessary for Pollock's full brilliance to emerge. Some of his greatest works, including "Lavender Mist," were painted there, and his studio, left just the same as the day he died, is still open to the public today, complete with drips. Willem de Kooning and his wife, Elaine de Kooning, came too, followed by Alfonso Ossorio, who bought the famous estate, The Creeks, of Adele and Albert Herter fame, and brought it back to prominence as a haven for artists and the arts.

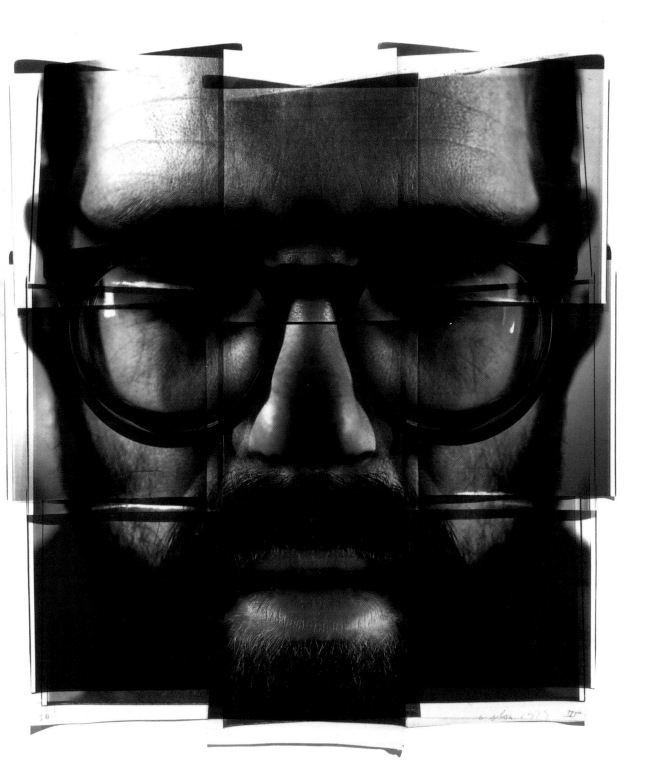

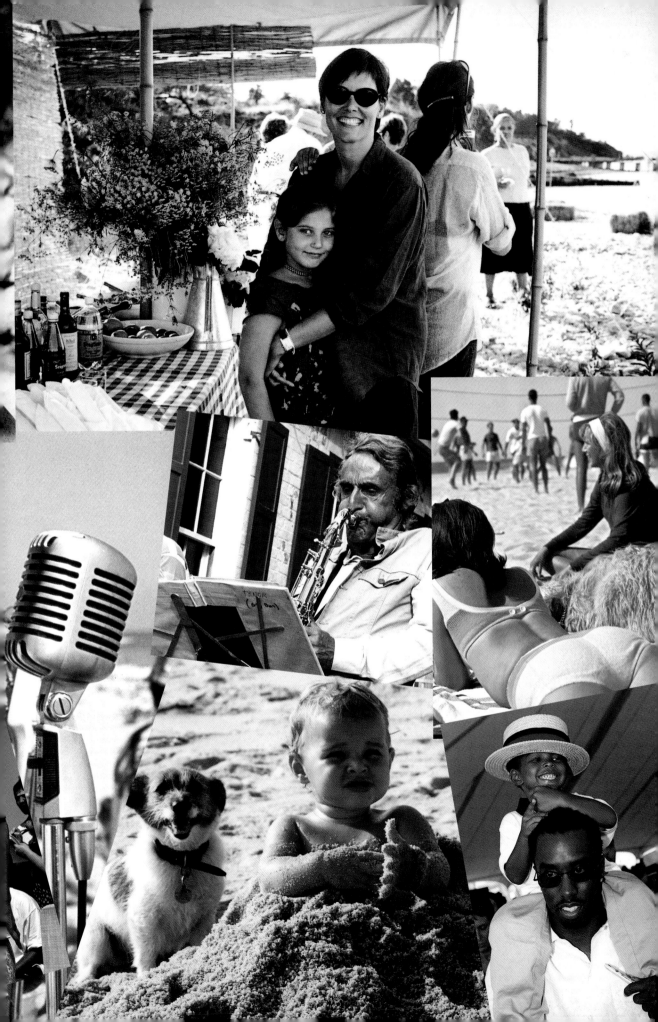

After the 1950s, literally hundreds of artists started coming. The list reads like a who's who of the art world. They all used to meet on Georgica Beach, then called Coast Guard Beach, in East Hampton. Underneath the observation tower they set up a café, where one was "neither host nor guest," says Brach. The artists would place their blankets into roughly concentric circles according to an established pecking order. The number one rule was that collectors and artists did not intermingle. It was rare to see a collector like Ben Heller, Donald Blinken, or other wealthy homeowners sitting with the artists. Earl Loran, a professor at University of California at Berkeley would hire young artists as art teachers for a semester at Berkeley in exchange for favored blanket spots. The artists themselves decided who would sit where according to who they believed was the most talented; Pollock rated high, as did Willem "the King" de Kooning.

Another legendary summer pastime of the artists' community was the weekly softball game. Sculptor Wilfred Zogbaum had a beautiful lawn in the Springs which became the field for these infamous matches. Elaine de Kooning was responsible for the ball. One summer, Elaine initiated the game with a white-painted grapefruit, which for all intents and purposes looked like a regulation softball. When artist critic Harold Rosenberg, went up to kick it, "SPLAT." Everyone laughed but Harold, according to Brach. The next week, a painted and

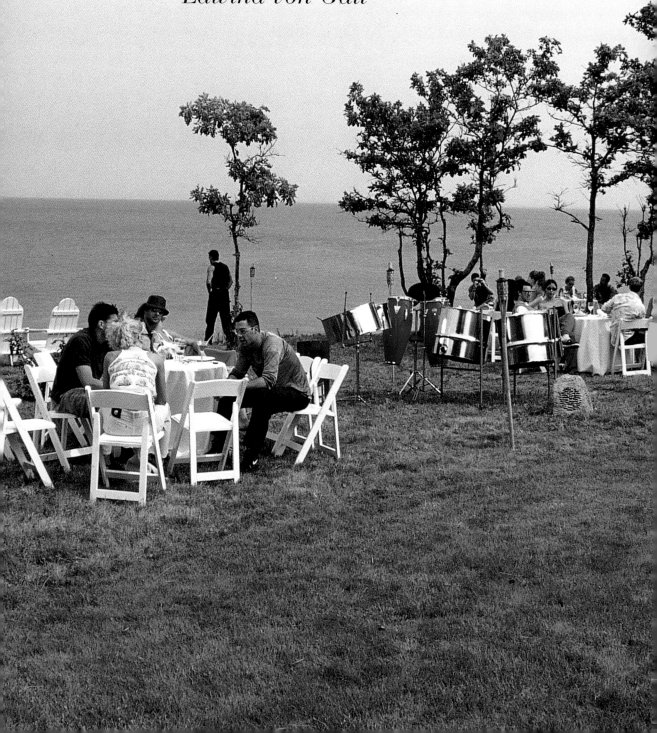

"The Hamptons is the place I hate to love. Everything negative people say is true. But when I'm here, I'm so happy to be here. When I am in my house and in my garden, there is no place I'd rather be."
Edwina von Gall

shaved white coconut, with the milk still in, it was the softball; once again, "SPLAT." The game continues to this day in the guise of the "Artists and Writers" games, also known to the famous players as the "Con Artists and Check Writers" game.

Beautiful Georgica Pond, the sometimes ferocious, sometimes calm ocean, white sand beaches, great restaurants and a bustling social scene, make East Hampton an eclectic and fascinating place to visit. And who knows, you may be lucky enough to spot the likes of Martha Stewart, Richard Meier, Chevy Chase, Helmut Lang, Calvin Klein, Donna Karan, Puff Daddy, or Russell Simmons if you're lucky.

OPPOSITE: *White Party hosted by Sean "Puffy" Combs on the 4th of July, 1998.*

PAGE 114-115: *Swans walking along East Hampton.*

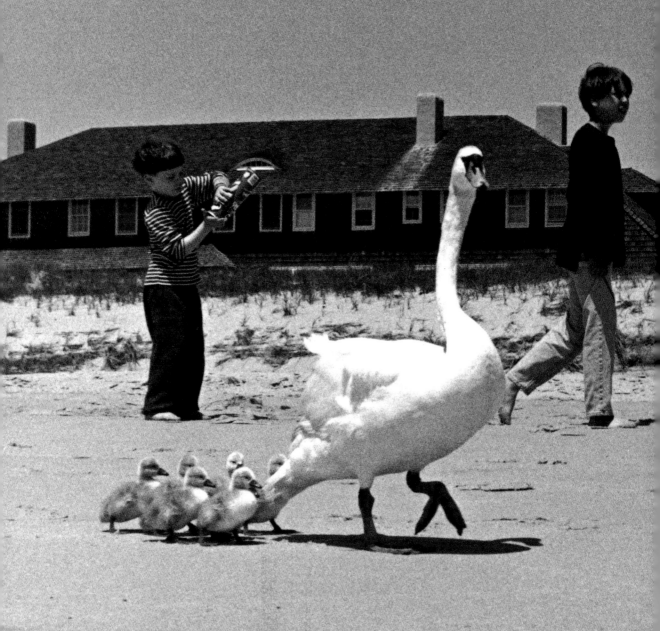

Amagansett

Through sunshine and snow, residents of Amagansett could rely on Stephen Pharoah Talkhouse, a Montaukett Indian, to get their mail to them safely every day. Always on foot and always in good humor, Talkhouse—nicknamed "The Walker"—was as much a part of this town's character as the Atlantic double dunes. Locals like to tell how one day someone pulled up beside Talkhouse striding along on his route and offered him a lift. "I'll get there faster on foot," was his tart reply, much to the delight of everyone. And, of course, he was right. Though Talkhouse has since passed away, more than half the charm of this tiny town is its sense of community. The volunteer fire department has protected Amagansett and nearby Napeague for many, many years. Property taxes in Amagansett are some of the highest in the Hamptons, but that is okay since the schools and the roads are perhaps the best in the area. Many celebrities have found solitude here, too. The late John Kennedy Jr. owned a weekend beach house on the Ocean side of Amagansett, and Alec Baldwin and Kim Basinger kept house directly behind the town.

Home to Hren's Nursery, Amagansett Wine Shop and the restaurant Lunch—which seems to feed most of the Hamptons

OPPOSITE: *Marilyn Monroe. She and husband Arthur Miller spent their honeymoon in Amagansett.*

PAGE 128-129: *Lazy Point in Napeague between Gardiner's Bay and Napeague Harbor is the only part of the Hamptons that holds no price tag. All of the property can be leased by the trustees of the East Hampton township. Locals are typically fishermen and windsurfers.*

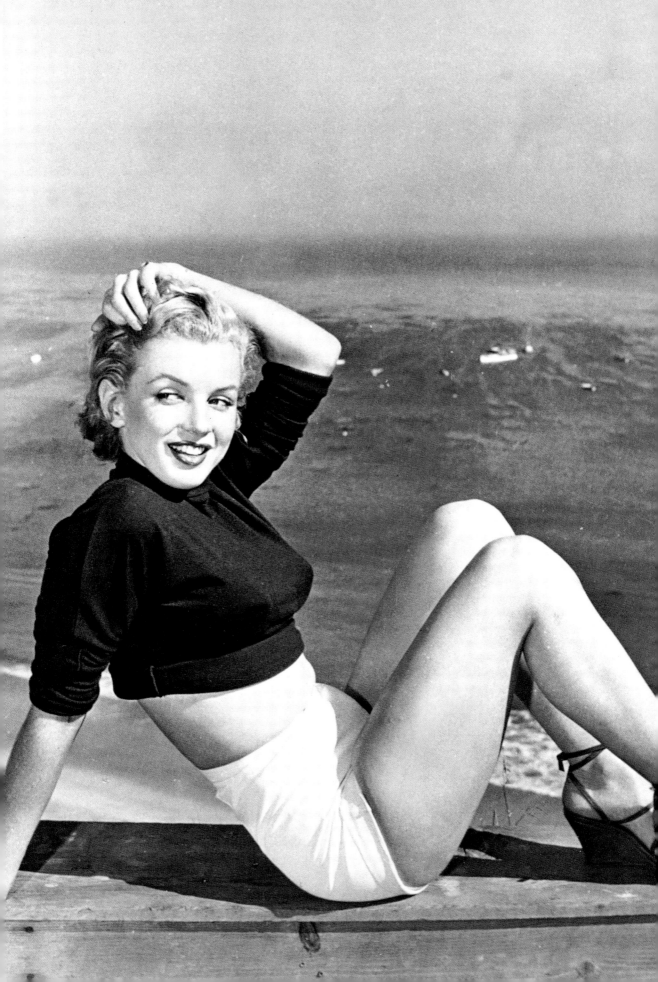

"Stop whining. This is a great place to live." *Henry H. Hildreth*

on weekends—Amagansett is a favorite destination for people from the entire region. The Lobster Roll restaurant, known for its hot dog bun sandwiches oozing with lobster, is said to enjoy a worldwide reputation. Every Saturday and Sunday throughout the summer, the farmers' market is hundreds deep. In Napeague Bay the fish farm is the best place to buy and eat lobsters, as long as you don't mind hissing swans.

Though the town itself is tiny, beautiful Amagansett is vast. It is the throat of the the South Fork where East Hampton funnels into Montauk. Known for its famous and vigilantly protected double dunes—which start at Wiborg Beach in East Hampton and end three miles into Amagansett—it provides access to some of the best fishing around. Indeed, fish are so abundant that at one time they sold for as little as a penny a fish.

Amagansett started to grow from a tiny fishing and farming village in the 1860s during the boarding house era, when tourists from New York City needed places to stay. In the early part of the century, Procter and Gamble, among other Cinncinatti investors, created the Devon colony, a series of

ABOVE: *Lazy Point in Napeague, between Gardiner's Bay and Napeague Harbor.*

OPPOSITE: *Interior of a home in Lazy Point.*

PAGE 133: *Actress Uma Thurman photographed by Gilles Bensimon for* ELLE *magazine in 1999.*

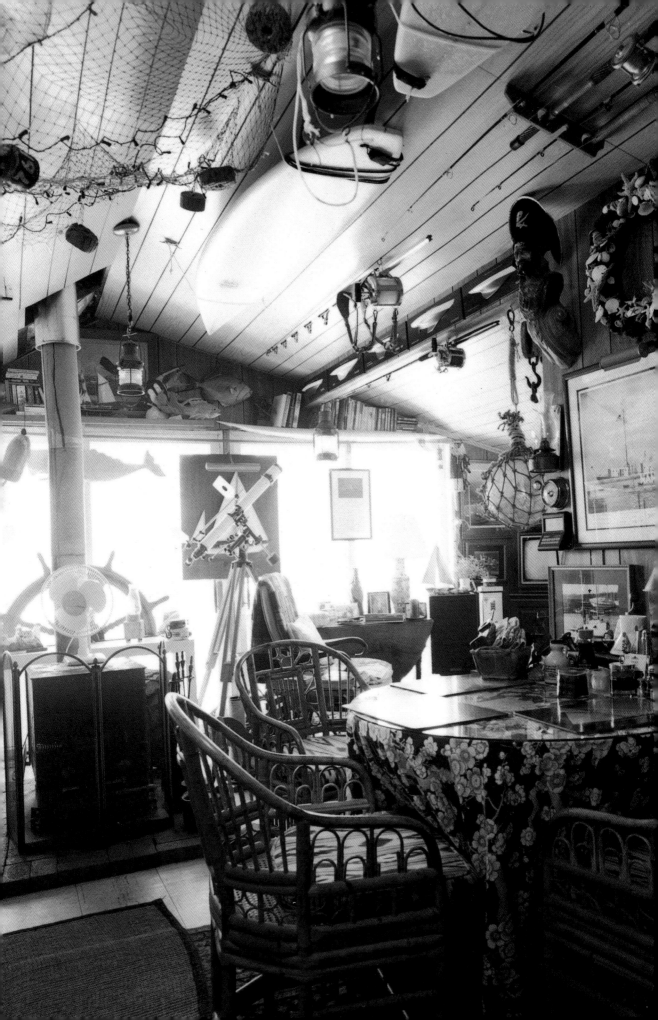

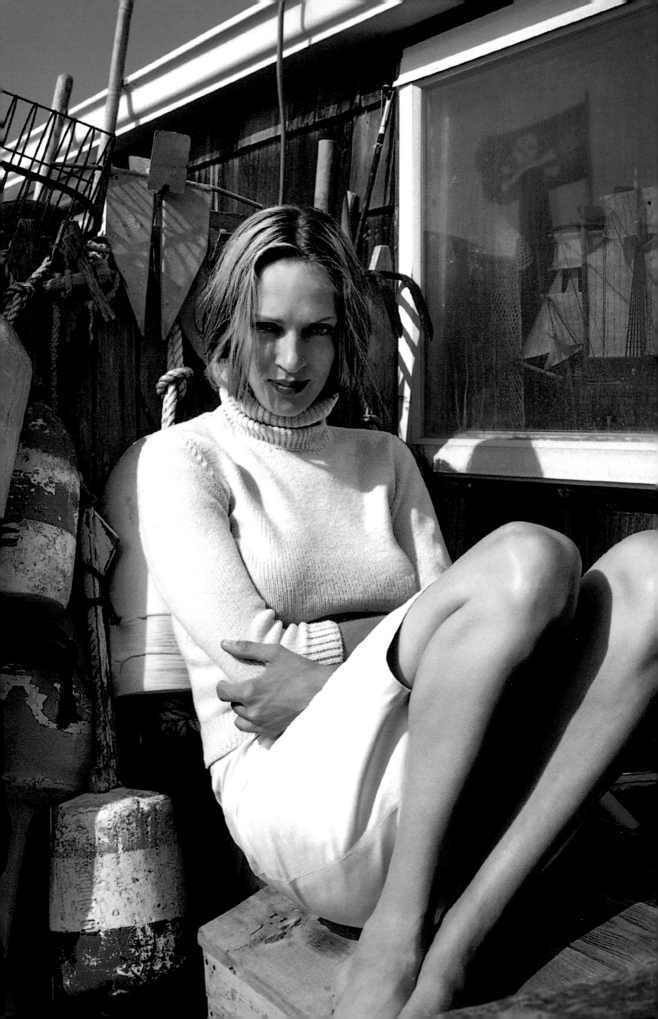

concrete stucco homes on the bay side that still exist today. The Devon Yacht Club, which dates back to that time, now offers instruction for our next America's Cup prodigies. Industry thrived here too. In a typically American story, one enterprising company built a factory that they called "Promised Land" so their advertisements to lure cheaper labor from the South could enticingly read "come to the Promised Land." Imagine the surprise of gullible workers who were looking for a ticket to freedom and were instead faced with the prospect of working and living near a foul smelling fish-processing factory that manufactured glue out of fish bones!

Lazy Point, the windsurfing area on Napeague Harbor, is the only part of the Hamptons that holds no price tag. Lazy Point belongs to the town and the fisherman's cottages that dot the landscape can only be leased, and cannot be sold.

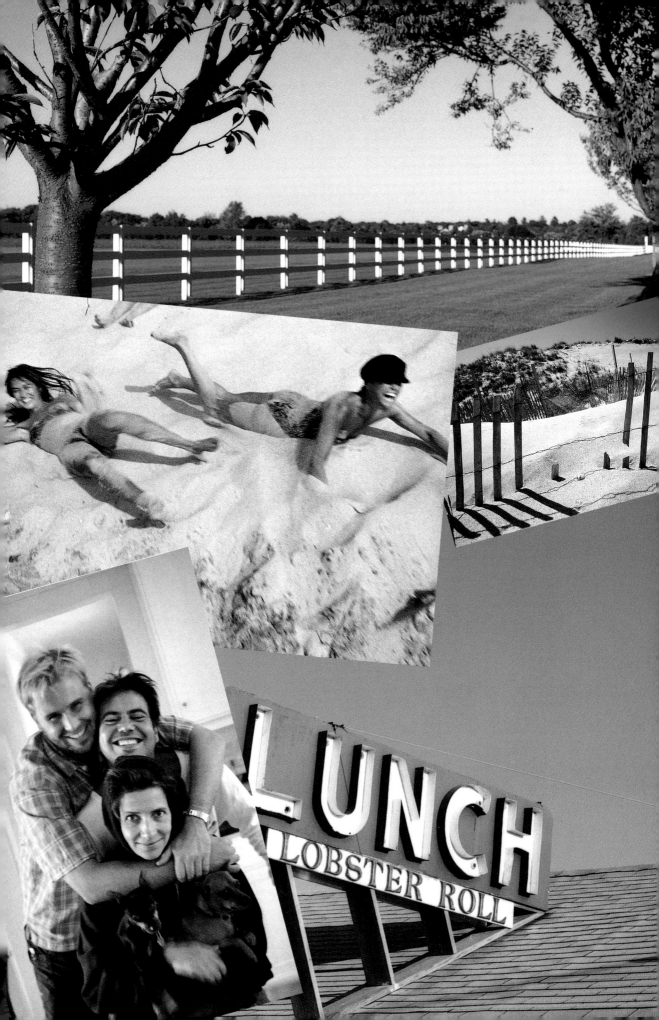

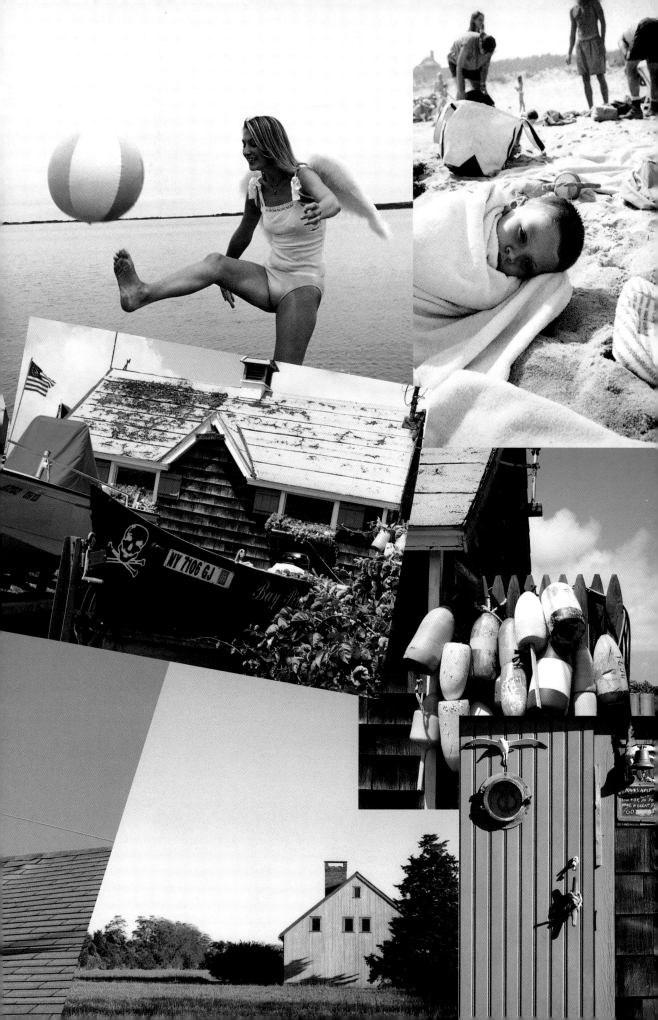

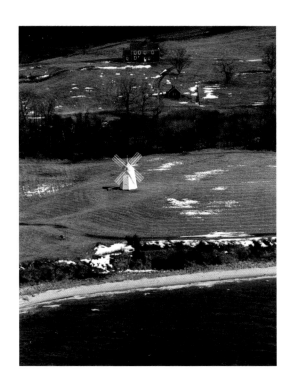

Gardiner's Island

With South Fork real estate at a premium, it would seem unlikely that an entire island could still be owned by only one family. But it is. Gardiner's Island, which sits in the bay between the north and south forks, has been owned and run by the Gardiners since 1638, when Robert Lion Gardiner bought it from the Montauk Indians for some coats, rum, a gun, and a dog. Pioneer, soldier, and later, diplomat (also the father of the first English girl born outside of Connecticut, as he was proud to proclaim), Gardiner built his homestead on this tiny island—only six miles long and three miles across—that still bears his name.

Gardiner was unusual in his day, not only because of his physical stature—he was rather tall for that time—but for his progressive attitudes toward dealing with potentially hostile Indians; he even took the trouble to learn their language. Originally posted in Connecticut to combat the Pequot Indians, he was sent to the South Fork of Long Island in the 1630s. Gardiner immediately set about finding peaceful ways to live together with the local Indian tribes rather than having to constantly watch his back. This turned out to work greatly in his favor as he eventually became not only the

ABOVE: *Gardiner's Island windmill on the west shore, near Cherry Harbor, was built in 1815 by Nathaniel Dominy V for John Lyon Gardiner.*

OPPOSITE: *Robert Gardiner stands at the marker on Gardiner's Island commemorating the spot where Captain Kidd allegedly buried his treasure in 1699.*

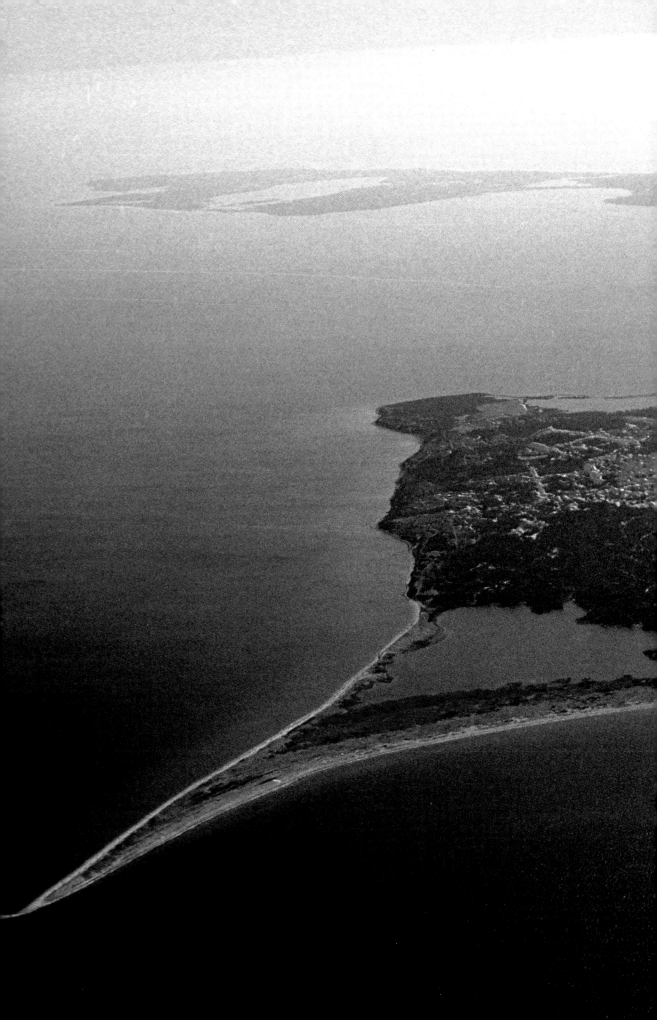

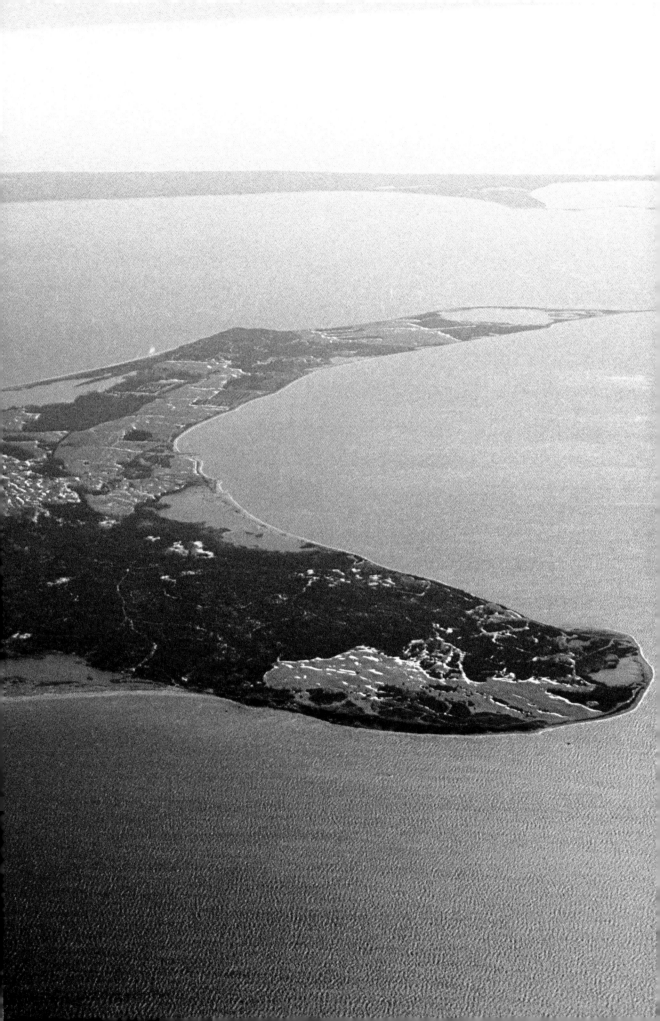

owner of Gardiner's Island (then called the Isle of Wight), but the recipient of thousands of acres of land as a present from chief Wyandanch after convincing a rival chief to release Wyandanch's daughter, who had been kidnapped on her wedding night.

Gardiner's Island is also famous as the real "Treasure Island." Passing through in 1699 from a particularly successful raid, the famous pirate Captain Kidd needed a place to stash the gold and jewels, and the island seemed like just the place: remote, wild, and uninhabited. Legend has it that Kidd threatened the Gardiners with something pretty nasty if they talked. Although he never came back to claim the stash, having been hanged back in England on trumped up charges, others did.

Today, the island is home to some of the most lush and important virgin forestland in the East and 27 miles of untouched beaches tantalizing boaters who venture too close. Although uninvited visitors are strictly forbidden to set foot on the island, once or twice a year, Robert David Lion Gardiner, namesake of his illustrious ancestor, takes people over in a motorboat so they can see this marvelous place for themselves.

Sadly, Gardiner and his relatives are now engaged in a legal battle for the island. Left in a trust to Robert Gardiner and his sister—who passed away several years ago leaving her half to her daughter—the fate of the island is now hotly contested between the two joint heirs.

OPPOSITE: *Manor House (brick) aerial Gardiner's Island. The 28-room brick Manor House on Gardiner's Island was built to replace the third Manor House that burned in January 1947.*

Montauk

On the easternmost tip of the South Fork lies windswept Montauk. Stunning dunes with dramatic cliffs, luminous harbors, and 20 miles of coastline make this otherwise stark landscape perhaps the most romantic of the Hamptons. The 9,800-acre peninsula was not heavily forested like other areas further south and was therefore used as grazing land by the settlers in East Hampton, who bought it from the Montauk Indians in 1660 for about 100 pounds sterling. The first settlers to build homes on this desolate but beautiful stretch came relatively late, in 1774, and made good use of its open fields as pastureland. Montauk was home to the first ranches in the new world.

As remote as it is, Montauk has seen its share of history. George Washington declared Montauk a point of entry in 1795 and gave his authorization to build the Montauk Lighthouse, which was completed in 1796 and is now the fourth oldest working lighthouse in the United States. In 1839, the infamous "Amistad" vessel was anchored off Culloden Point carrying the 40 mutinous African slaves who would eventually be defended by John Quincy Adams in the U.S. Supreme Court. In 1898, Theodore Roosevelt brought his

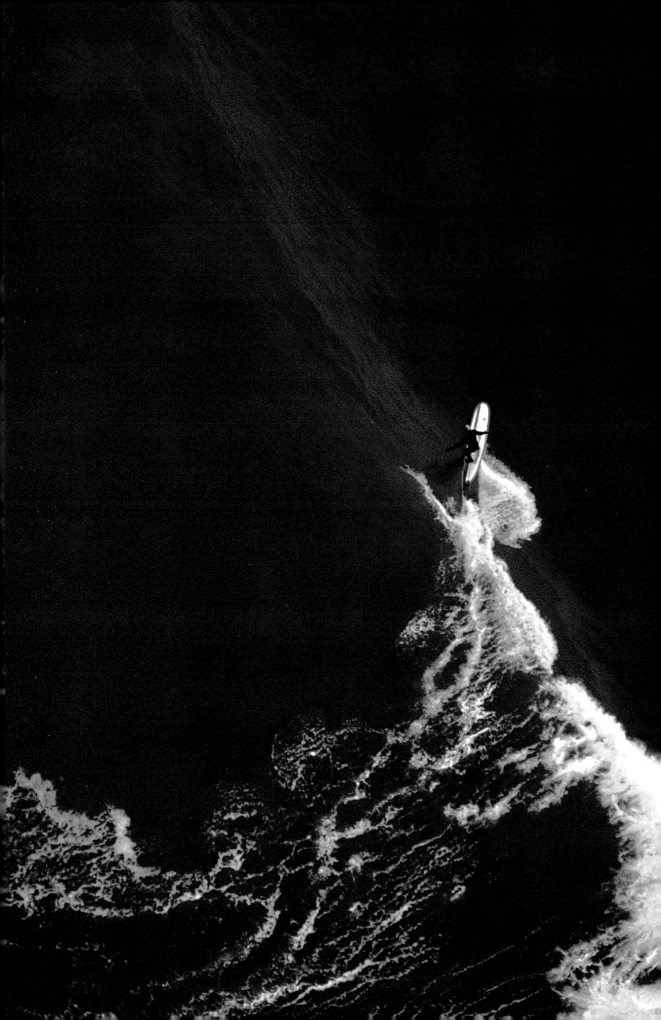

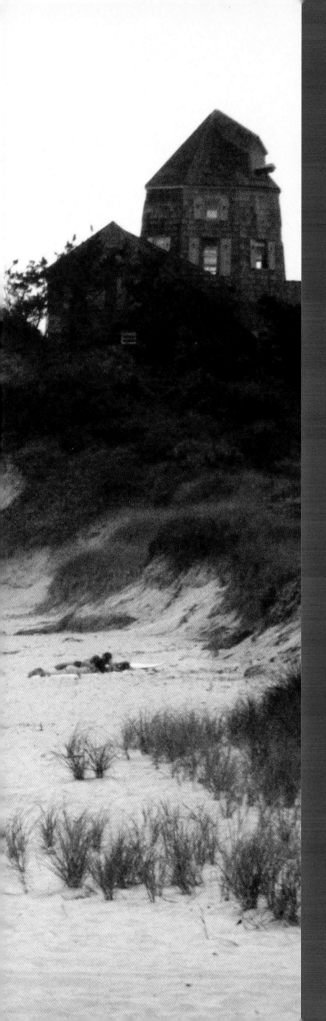

"Despite the development and accepting the changes, Montauk's essence and spirituality prevail. The light, the ocean bluffs, the breaking sea, all in celebration."

John H. Gosman Sr.

1,200 "Rough Rider" troops to Montauk after the Spanish-American War, when its remoteness made a perfect quarantine for soldiers recuperating from the Yellow Fever they contracted in Cuba. And, in 1943, local residents were given 30 days to move from their houses so the U.S. Navy could use the area to build a torpedo testing site. One tantalizing rumor alleges that the now abandoned spot was actually used for government experiments on invisibility and radio mind control.

In the early part of the 19th century there were as few as seven homes on the peninsula and no road access. But, in 1882, a group of prominent businessmen who wanted to found an exclusive hunting and fishing colony hired McKim, Mead and White for the job. Stanford White loved the landscape and eventually built many homes there, at least two of these dwellings came entirely by boat and had to be brought up the sides of steep cliffs since the railroad did not extend that far until 1895. Shingle style homes with wide porches were the common style, but White's homes, as to be expected, were uncommon examples of this style; mansions with

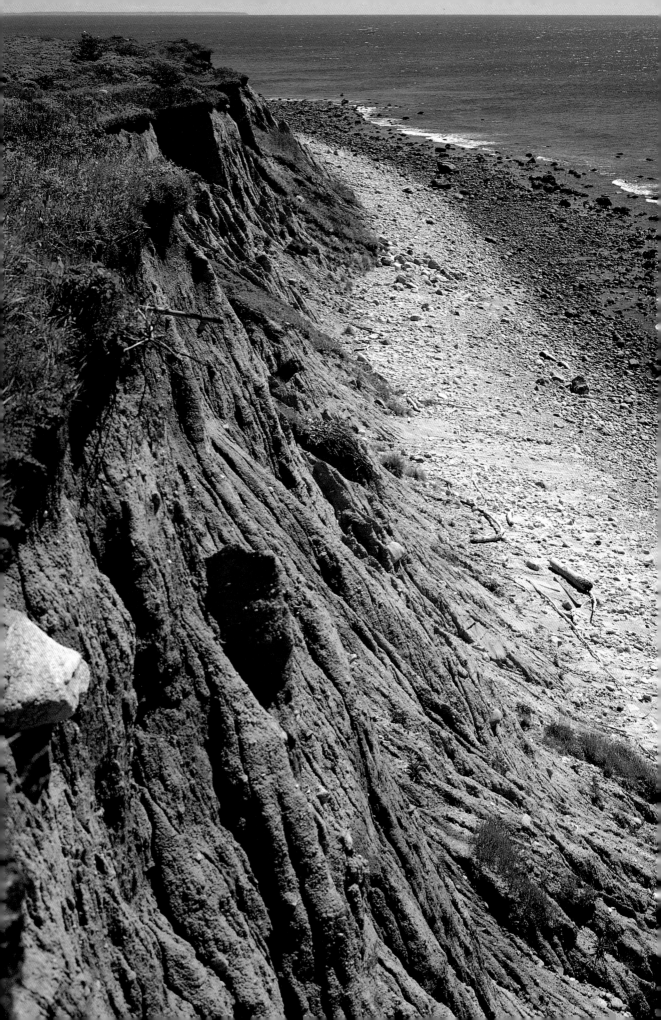

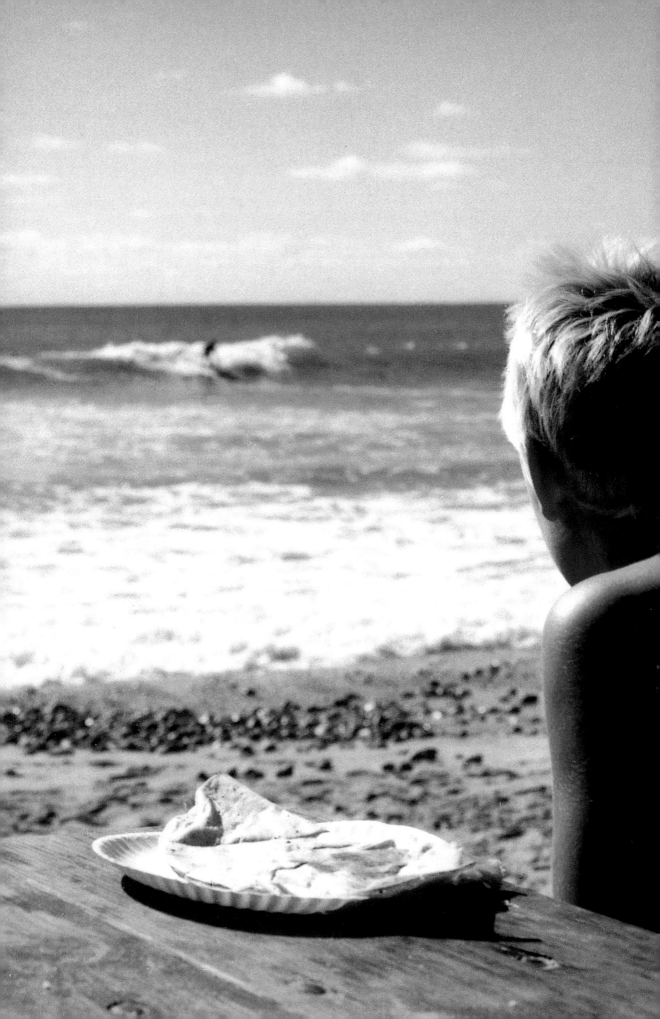

"I don't really see Montauk as part of the Hamptons. Surfing in front of Andy's house on a sunny day, Montauk is like Mexico, and on a grey day it is like Wales."

Julian Schnabel

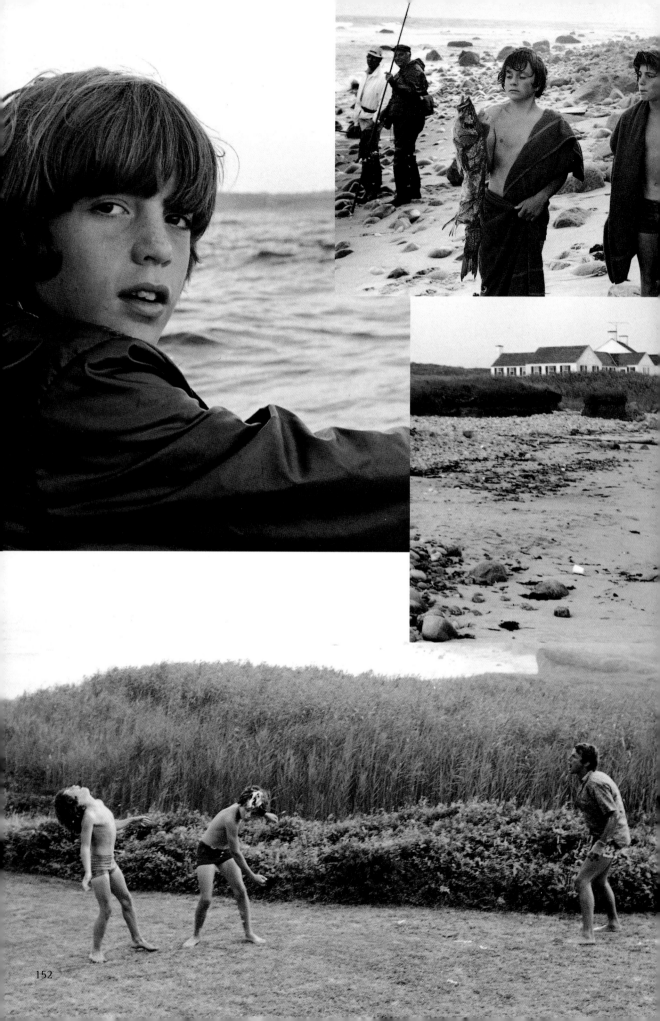

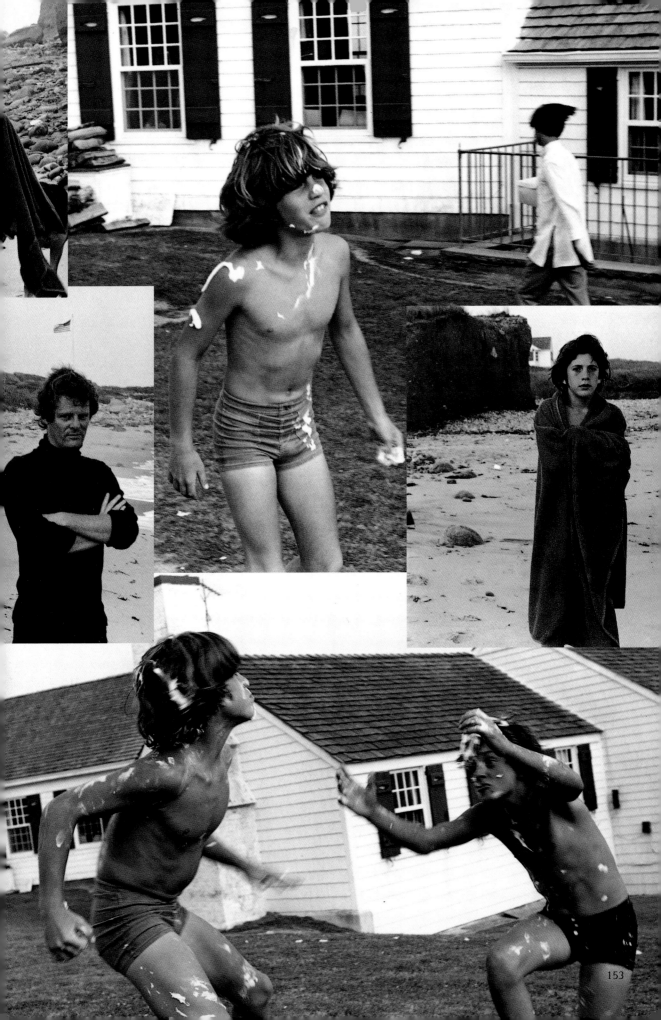

153

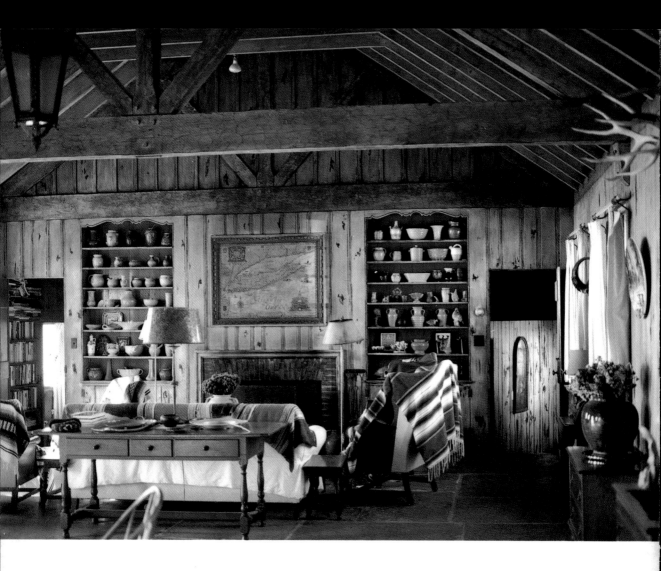

gorgeous mahogany woodwork, winding staircases, and beamed ceilings.

Montauk seemed strangely resilient to development, however. After he successfully uprooted what remained of the indigenous Montauketts, Arthur Benson and his heirs owned Montauk until 1895, when it was sold to Charles Pratt and Austin Corbin Jr., who hoped that Fort Pond Bay would become a transatlantic shipping port. When that plan failed, 9,000 acres, with nine miles of waterfront, were sold to Carl Fisher, a real estate baron who was instrumental in the development of Miami Beach. With so much land and beach property, Fisher had every reason to believe that Montauk would be "the Miami Beach of the North," but got only as far as Montauk Manor—completed in 1927—when the depression sent his dreams for Montauk out with the tide.

Development in Montauk was slow, but once it started, it mushroomed in some strange and wonderful ways. With the advent of American mobility in the 1930s and 40s the slogan "Buy a Car, Travel, See America" was taken much to heart. Even remote Montauk was discovered by people in mobile

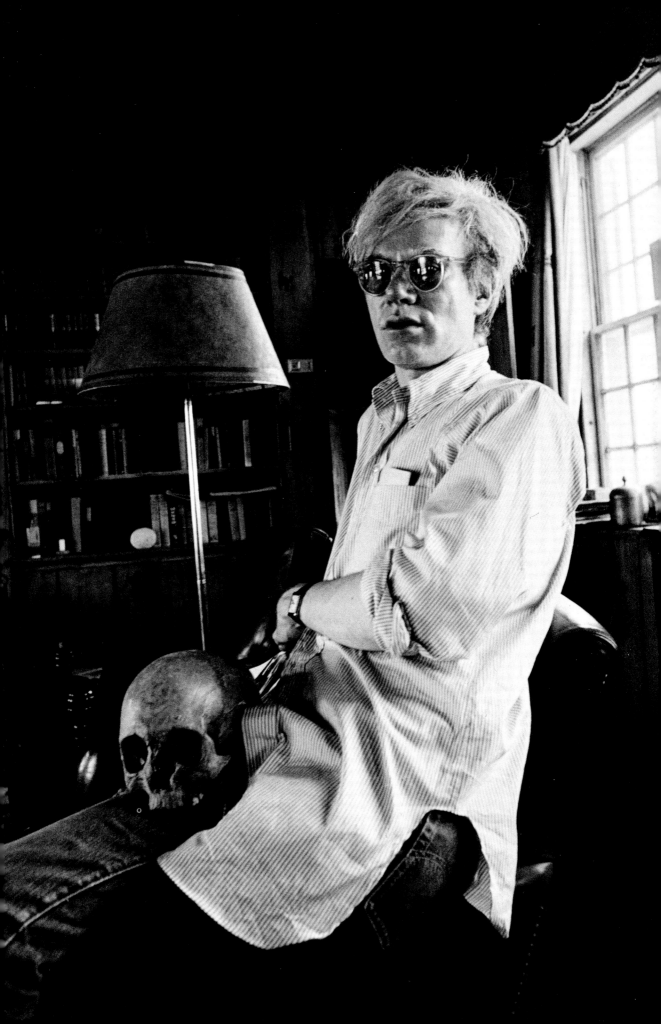

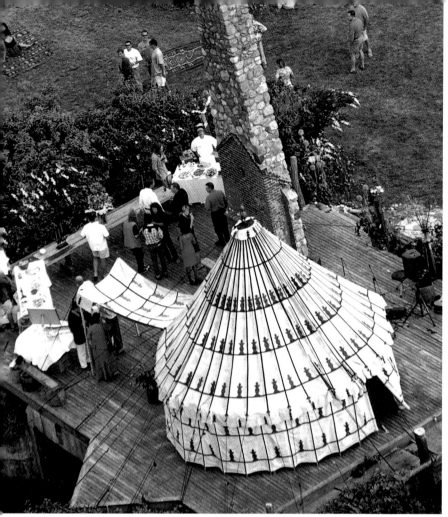

ABOVE: *This Moroccan tent, commissioned by Najma Beard, is put up during the summer on the site of the burnt landmark windmill home. "It is my summer house," says Najma. Halston lived in it for a while and redecorated it entirely. Then when Beard got it back, it burnt. Najma's inspiration was that she wanted the new structure to be like a phoenix.*

homes looking for a place to settle. Trailer parks soon colored the landscape and over the years have mellowed into quaint little neighborhoods with flower-lined paths and pretty fences. Those living in the trailer parks have the best deal in the Hamptons—great views for the right price. Now, Montauk is an amalgam of styles: from the old shingle cottages, huge Victorian homes, truly monstrous modern buildings, and ultra-sleek postmodern mansions.

There is much to do in Montauk. People come from all over the world to surf its famous waves, hike around the beautiful sea bluffs and state parks, ride horses at Deep Hollow ranch—the oldest ranch in the U.S.—and eat some of

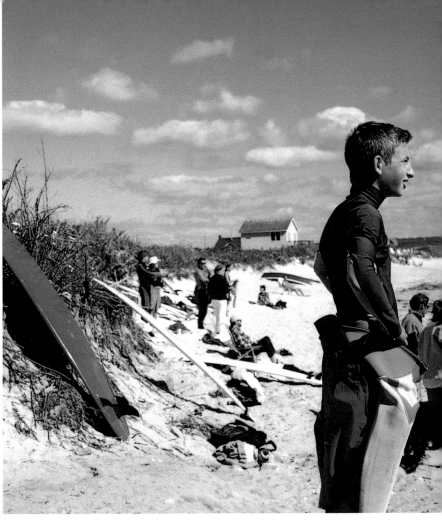

MIDDLE: *Surf casting on the beach.*

PAGE 158-158: *Here, artist Julian Schnabel paints the "Conversion of Paolo Malfi." The subject died in a motorcycle accident. Schnabel loves to paint outside to see his paintings in all different lights. He also loves to be affected by all kinds of weather—the smell of oil and sunshine reminds him of being a kid.*

the freshest lobster on the East Coast at Gosman's family restaurant. Like the rest of the Hamptons, Montauk is no stranger to the arts. Playwright Edward Albee opened his play "Seascape" at the Bay Street Theatre, and established a foundation in Montauk where each summer around two dozen playwrights, poets, novelists, painters, sculptors, and photographers are given one-month residency in a converted barn.

And there is no lack of glamour and celebrity either—Warhol started it with the likes of Liza Minnelli and Mick Jagger running around his estate during the summer. Others like Paul Simon, Peter Beard, and Richard Avedon can be spotted among those who come to enjoy this paradise at the end of the road.

66At night, I stand around with my friends and paint. Most of the paintings I have done in the past twelve years were painted outside Montauk.**99**
Julian Schnabel

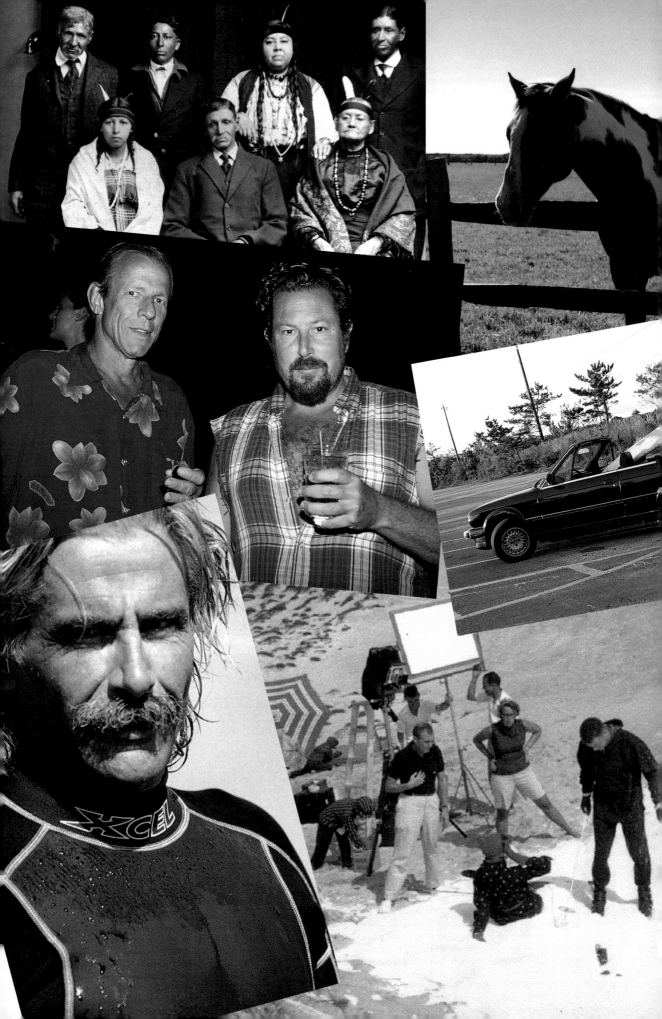

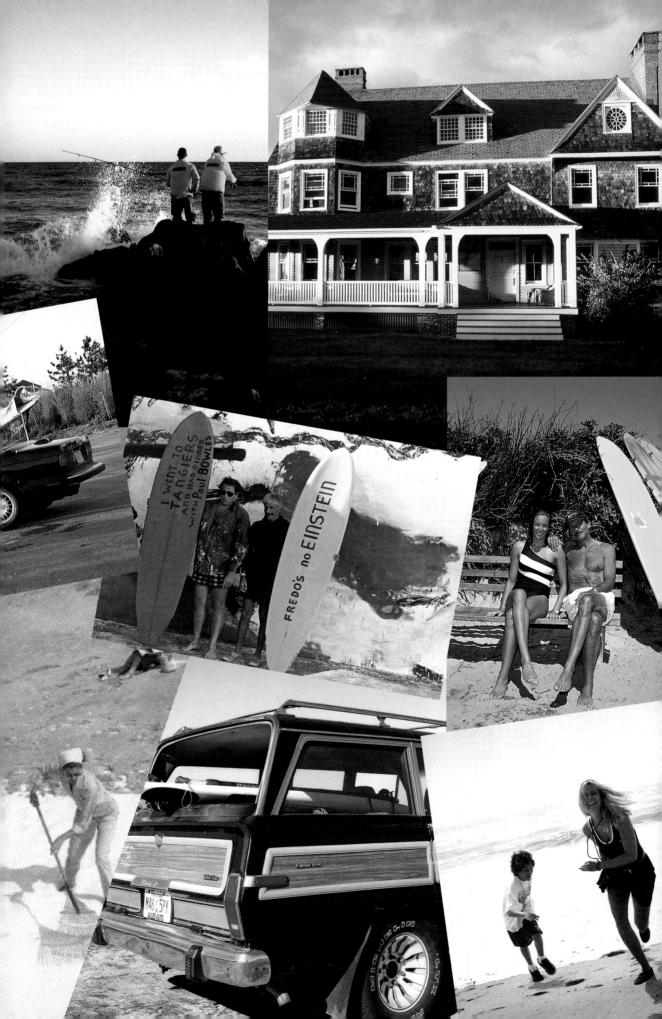

It's the kind of place

It's the kind of place where most residents only live six-teen weeks out of the year. It's the kind of place the where children can still run freely down the beach. It's the kind of place where you see a woman walking down the street with her son, you say "hello" as if you know her, and realize it is Julianne Moore. It's the kind of place where you can buy fresh produce from the Farmer's Market in Amagansett or eat sushi, Mexican, Japanese, Italian, or Chinese, just to name a few. It's the kind of place where some of the lobsters are over 50 years old, and some of the fishermen are much older. It's the kind of place where you can have a landscape architect design your garden, or mix any flowers together, and no one com-ments. It's the kind of place where Martha Stewart trans-formed the Monogram Shop over owner Valerie's garage into a dining room for a photo shoot. It's the kind of place where Eleanor Mondale can keep her collection of mini ponies in her back yard. It's the kind of place where Jimmy Buffett per-forms casually in a friend's backyard while kids run and play around the barbeque. It's the kind of place where Cornell University owns land for butterfly observation. It's the kind of place where director/producer Barry Sonnefeld's wife can

ABOVE: *Designer Azzedine Alaïa walks on the beach.*

162

learn to fly. It's the kind of place where the Long Island Expressway ends at exit 70 because they didn't want too many people coming out. It's the kind of place where private jets come in from Los Angeles just for the weekend. It's the kind of place where people talk about not how many frequent flyer miles they have, but rather how many hours they have left on their private charters. It's the kind of place where there is only one McDonald's within 50 miles. It's the only place where movies like *Pollock* can be filmed on location. It's the kind of place where 350-year-old trees give an old-world character. It's the kind of place where you'll find the children of tycoons selling 10-cent lemonade in front of their million dollar homes. It's the kind of place where you might sit next to a Kennedy while eating grilled cheese at the Candy Kitchen in Bridgehampton. It's the kind of place where you might see a farmer sitting on his tractor making trades over his cell phone. It's the kind of place where a steak restaurant owned by a Greek brother and sister boasts its own art collection: four paintings by Julian Schnabel, one Larry Rivers, one David Salle, and a Phoebe Leger self-portrait. It's the kind of place where my friends tease me for raking my own leaves. It's the kind of place where Shabbat services is performed Friday nights at Main Beach in East Hampton. It's the kind of place that has its own bus called the Hampton Jitney, with attendants who serve you snacks with a newspaper. It's the kind of place where the Jitney's competitor, the Luxury Liner, has first-class seats and television. It's the kind of place where some people don't go out to the movies because they have a screening room at home with seats that recline. It's the kind of place where the busiest establishments are the movie theater and the ice cream store. It's the kind of place where someone built his own sand bag dune to prevent erosion, only to see the Atlantic ocean wash all his troubles away the very next day. It's the kind of place that boasts a town voted the most beautiful in America. It's the kind of place where you take your pick-up truck out at dusk in Montauk to spot deer and your friend says, "there's Billy Baldwin's house." It's the kind of place where Arthur Miller and Marilyn Monroe spent their honeymoon. It's the kind of place that homes Hildreth's, the oldest department store in America, and Deep Hollow Ranch, the first horse ranch in the country. It's the kind of place where just as you are about to drive home, the sunset sweeps across the vast sky in an orange or pink so vibrant that you have to pull over to watch it.

the
a
try

Hamptons
e FULL
again Later
©Needles

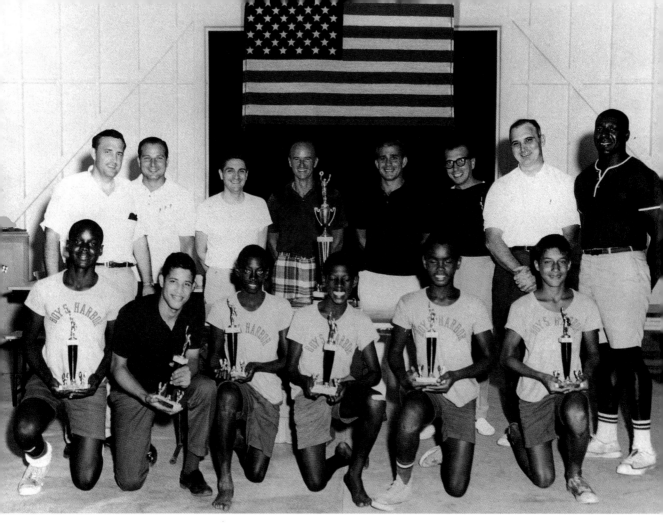

Boy's Harbor

All of the author's proceeds for this book will be donated to Boy's and Girl's Harbor in New York City and East Hampton. Special thanks to Tony Duke and his family. Tony not only entertained me with stories of the past, but intrigued me with facts not many have explored.

In 1950, I finally found the perfect piece of land in East Hampton—a vast tract on Three Mile Harbor. I opened Boy's Harbor there in '51, and our summer operation is still there.

I knew a little about East Hampton in those days. I spotted the land where the camp is now from the air one day while flying down from Massachusetts, and managed to purchase it for a very low price. We had no electricity or telephones those first couple of years. I liked it that way. But for health and safety and other practical reasons, we gradually developed the camp into something more substantial. We built decent cabins, a mess hall,

ABOVE: *Tony Duke, center, with young men of Boy's Harbor, 1950s.*

and a playing field. We developed educational and athletic programs, instituted a large, ever-growing service center in New York City and over the years have kept track of thousands of Harbor alumnae. The alumns, more than anything else, prove the efficacy and success of the Harbor's (now boy's and girl's Harbor's) system of helping inner-city kids and young adults meet difficult challenges at home, in school, and in general. Most enrollees have difficult circumstances to overcome, as you can imagine. Poverty, complicated family situations, poor housing, insufficient educational opportunities, the lure of drugs and other street crimes, and so on. The Harbor's mission has always been to boost these young citizens upward; to offer the training and education and discipline it takes to help them reach their potential as individuals living in a democracy.

I was brought up during the Great Depression of '29. I was 11 years old when it hit, and I saw around me the devastation it wrought. Several fathers of kids in my private school class committed suicide. Some friends of mine were pulled out of school and disappeared from my life. I used to go into the city with my stepfather, he was a successful architect, and visit the buildings he designed. Often we would pass bread lines—long lines of unemployed, sparsely dressed men and women lined up at soup kitchens or to receive baskets of apples they would then sell.

At the age of 15, I tried to get a summer job. We lived a pretty comfortable life in Southampton those summers. I got bored with the beach club routine and sought something more interesting. I was a reasonably good athlete—a boxer, hockey player, swimmer, and football player, and when my school (St. Paul's in New Hampshire) offered a few of us jobs with room and board in a camp for "delinquents and disadvantaged city kids" I jumped at the opportunity. The city kids came from New York's Lower East Side, and Boston's Back Bay area, and were all sons of immigrants: Italian, German, Swedish, Irish, Russian, Hungarian, Greek, Polish, etc. They were allegedly delinquent—many with police records involving pick-pocketing, street fighting, pilfering goods from stores—and so on, but many were simply "poor" kids.

I really enjoyed my job as a junior councilor, then a senior, or regular councilor. For three years, I had a cabin full of the same boys each year. They were mostly great kids—energetic, smart, and eager to learn how to get along. The year I left, 1937, my cabin kids were 14 years old and had reached the age limit.

I found myself driving a bunch of these boys down from New Hampshire to New York City at the end of that summer. We were yelling, shouting at other cars from my beat-up old Ford truck, and generally enjoying ourselves. As we approached, I blurted out "Well maybe, my friends. . . that is, maybe a couple of other councilors and I could start a small camp you could come to." We did.

It has grown over the years. 43,000 kids have come up through all our pipelines: the city programs, summer camps and so on. Some of our alumni are extraordinary: one civil court judge; a head nurse at Mt. Sinai Hospital; attorneys; doctors; Ph.Ds; a college presidential candidate; bank officers; police officers; military veterans of WWII, and the Korean War, Vietnam; and countless wage-earning, self-sufficient citizens.

Tony Duke

Bibliography

Brady, James. *Further Lane*. St. Martin's Press. 1997.

Breen, T.H. *Imagining the Past: East Hampton Histories*. Addison Wesley Publishing Company, Inc., 1989.

Donnelly, Honoria Murphy with Richard N. Billings. *Sara & Gerald*. Holt, Rineheart & Wilson. 1984.

Frank, Abe. *Together But Apart: The Jewish Experience in the Hamptons*. Shengold Publishers Inc. 1966.

Gaines, Steven. *Philisterts at the Hedgerow*. Little, Brown & Company. 1998.

Geus, Averill Dayton. *Sea to Sea*. Phoenix Publishing. 1999.

Goddard, David. *The Maidstone Links*. Maidstone Club, Inc. 1997.

Green, Louise Tuthill. *Images of America: Shelter Island, a Nostalgic Journey*. Arcadia Publishing. 1997.

Gruen, John. *The Party's Over*.

Long, Robert. *Long Island Poets*. The Permanent Press. 1986.

Munro, Eleanor. *Originals: American Women Artists*. Touchstone/Simon & Schuster. 1982.

Tomkins, Calvin. *Living Well is the Best Revenge*. E.P. Dutton. 1982.

Tomkins, Calvin. *The Other Hampton*. Grossman Publishers. 1974.

Tucker, Martin. *Long Island Writers: Confrontation, Poems, Fiction, Essays*. Long Island University Press. 1985.

Twomey, Tom. *Awakening the Past*. Newmarket Press. 1999.

Twomey, Tom. *Tracing the Past*. Newmarket Press. 2000.

Vaill, Amanda. *Everybody Was So Young*. Broadway Books. 1998.

Wettereau, Helen M. *Good Ground Remembered*. Academy Printing Services Inc. 1983.

Whitman, Walt. *Speciman Days & Collect*. Dover Publications, Inc. 1995.

Acknowldgements

Special thanks to Prosper and Martine for the opportunity; my husband and children for their support; my brother and sister just for being them; West Side Color Lab; B Lab; Matt Albiani for starting the project with me; Adam J. Roberts for finishing it; Doug Kuntz for inspiring me; Dorothée Walliser for teaching me the fundamentals of book publishing; Professor Alan Ziegler for all of his efforts; Jennifer Ditsler for her encouragement and persistance; Rene Reagan for making it come all together.

Thanks to: Edward Albee, Amagansett Lifeguards, Tom Ambrosio (Light House Museum), Bennett Ashley, Chuck Baker, Andre Balazs, Assouline Publishing, Fabien Baron, Richard Barrons, Peter & Najma Beard, Jonathan Becker, Gilles Bensimon, Susan Benson, Gert Berliner, Boys and Girls Harbor, Larry Gagosian & Bettina Sulser, Jean Bickley, Ross Bleckner, Christine Bobbish, Billy Bonbrest, David Bradenberg, Peter Brant, Bridgehampton Historical Society, Christie Brinkley, Dana Brockman, Guillaume Bruneau, Dana Buckley, Mark Bugzester (B Lab), Canio's Books, Tony Caramanico, Jay Chiat, Richard Christiansen, Chris & Stephanie Clark, Paul & Patty Cohen, Bob Colacello, Sean Combs, Ted Conklin, Barefoot Contessa, Marion Curtis, Wallace Daly, Dan's Papers, Diana Dayton, Patrick Deedes, Ellen Delsner, Patrick and Mia Demarchelier, James Devine, Aura Dimon, Frasier Docherty, Laura Donnelly, Larry Dowing, Suzy Drasnin, Russell Drumm, Anthony & Luly Duke, East Hampton Library, *East Hampton Star*, Todd Eberle, Arthur Elgort, Marissa Eller, Carlos Emilio, Mary Emmerling, Wei Eng, Lillian Epstein, Joe Eula, Luna Farm, Peggy Finelli, Tina Fredericks, Douglas Friedman, Steven Gaines, Bob Gallagher, Ina Garten, Didier Gault, Getty Museum, Claudia Ghetu, George Glazer, David Goddard, Peter Gong, John Gosman, Jr., John Gosman, Sr., Joshua Greene, David Gribin, Liz Gribin, Guild Hall, Bette Anne & Charles Gwathmey, Patrick Haley, John Halsey, Hampton Classic Office, Pamela Hanson, Helen Harrison, Haven's House, John Hersey, Henry Hildreth, Hidlreth's, Nature Conservancy, Jenny Hung, Dean Isidro, Mort Janklow, Douglas Kane, Eleanora Kennedy, Greg Kessler, Nicole Miller & Kim Taipale, Dorothy King, Lorraine Kirke, Calvin Klein, Kelly Klein, Marci Klein, Michael Koller, Ladies Village Improvement Society, Gus Laggis, Aerin Lauder, Lara Lerner, Ben Ligi, Peter Lindbergh, Noah, Giddeon & Kristina Loggia, Lisa & Natalie Lore, Carey Lowell, Didier Malige, Janet Marks, Albert Maysles, John McGill, Patrick McMullan, Joseph Mehling, Richard Meier, Roberta Meyers, Clifford Clark & Michael Briton Clark (South Ferry), Frank Michielli, Marcia Mishaan, Mihoko Miyata, Eleanor Mondale, Paul Morrissey, Glen O'Brien, Kevin O'Malley, Old Stove Pub, Peter Mgo, James Parker, PJ Parlette, Maryvan Pendl, Bob Pharoah, Kathy Piacentine, Daniel Popadick, Dan Rattiner, Tammi & Mike Reinhardt, Adam J. Roberts, Jeffrey & Margie Rosen, Ross School, Noel Rowe, Sag Pond Farm, David Salle, Allan Schneider, Tim & Helen Schifter, Julian & Olatz Schnabel, Stephanie Seymour, David & Juliet Shaw, Shelter Island, Randy Shindler, Barbara Sieff, Jean-Loup Sieff, Peggy Siegal, Matty Siegel, Russell Simmons, Murray Smith, Valerie & Hadley Smith, Tracy Bonbrest & Stuart Kreisler, Southampton Library, Frederico Sztryle, Simon Taylor (Guild Hall), The Blue Parrot, The Presbyterian Church, Uma Thurman, Trunzo Builders, Peter Tunney, Kevin Verbesey, Antoine Verglas, Edwina Von Gall, Warhol Foundation, Claude & Bruce Wasserstein, Warren Whipple, Dirk Whittenborn, Erin Williams, Tom Wolfe, Hal Zwick.

Photo credits